FIGURING OUT

PAINTINGS BY SAMUEL BAK
2017–2022

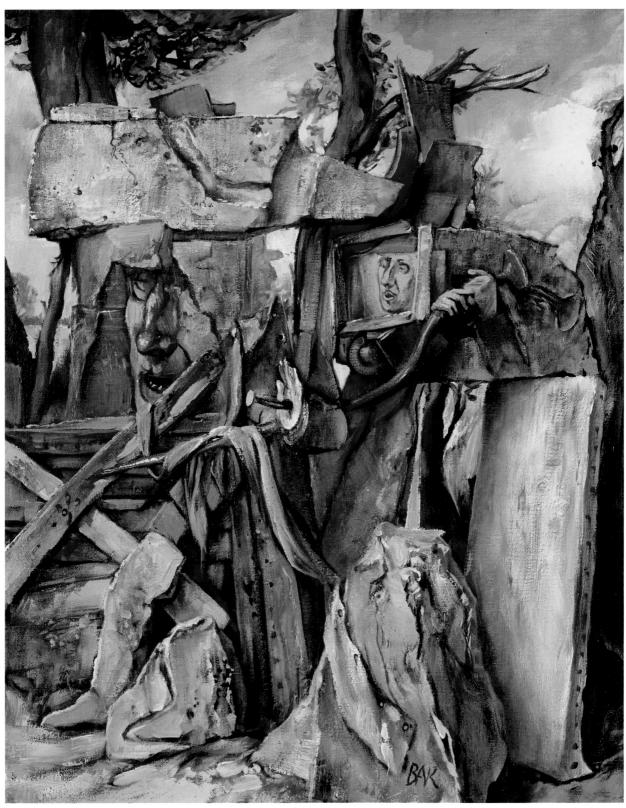

NAILINGS, D (SEPTET 4/7), DETAIL ~ 2021
Oil on canvas
20 x 16"
BK2642

FIGURING OUT

PAINTINGS BY SAMUEL BAK
2017–2022

~

by LAWRENCE L. LANGER and ANDREW MEYERS

Published by Pucker Art Publications

Distributed by Syracuse University Press

~

FIGURING OUT

PAINTINGS BY SAMUEL BAK

2017–2022

~

© Pucker Art Publications, 2022

Published by Pucker Art Publications
Boston, Massachusetts 02116

Distributed by Syracuse University Press
Syracuse, New York 13244-5160

Design by Leslie Anne Feagley
Editing by Jeanne Koles and Ellen Buchanan
Printed in Canada by Friesens Corporation

Library of Congress Cataloging-in-Publication Data available from the
publisher upon request.

ISBN: 978-1-879985-42-1

~

To Rimantas Stankevicius of Vilnius,

who by toiling to preserve the painful memory

of our mutual birth-town, joined me in my endeavors,

and infinitely enriched the course of my life.

~

With gratitude and brotherly love,

~ SAM ~

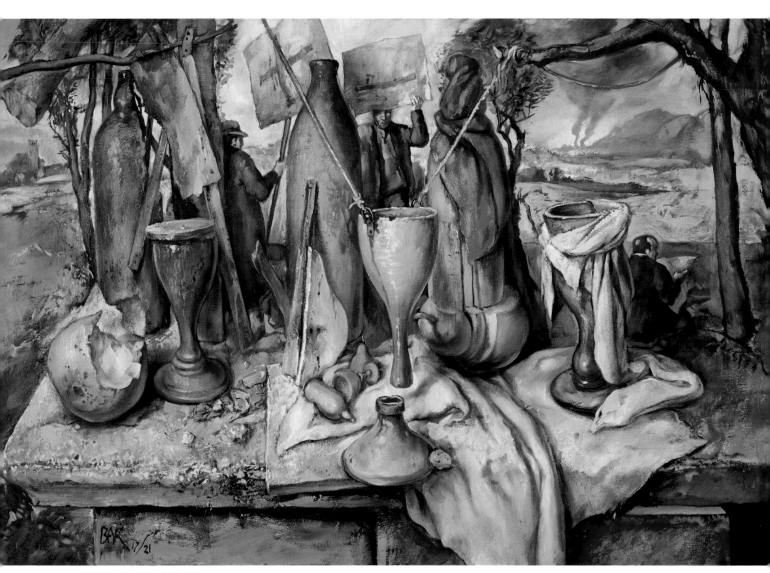

MORE OR LESS ~ 2017–2021
Oil on canvas
24 x 36"
BK2630

THE ABANDONED PROMISE OF PARADISE

by LAWRENCE L. LANGER

~

Art is a form of construction, but so is life: we piece together the fragments of our experience and try to make sense of them. Viewing the artistic creations of Samuel Bak requires a similar venture, but the visual world he offers us in *Figuring Out* is a wounded universe, most of its objects and persons pierced, dismembered and mercilessly assaulted by a variety of devices, chiefly hammers and nails, which are normally used to build or repair, not to damage or destroy. Bak's staging of a human and natural landscape in various states of stress will appear strange or surrealistic only to viewers who have not been paying attention to the slow surge in moral, social and cultural decline that has plagued our civilization during the past hundred years. The occasional appearance of Adam and Eve in the series, a pair struggling to restore some stability to their exiled lives, is a graphic reminder that the promise of Paradise has long since been abandoned with little evidence for its eventual return.

One of the unusual consequences of this grim conclusion is that the artist is implicated in his own challenge to his audience, skewered, as it were, by the very devices of his art. In *More or Less* (BK2630) we are presented with an array of familiar images—familiar, at least, to anyone who has been following the career of this prolific artist—and we greet them like old friends. We have met those goblets before in earlier works, and also the discolored bottles and floating trees and half-eaten pears. And the stone slab in the shape of an altar with the pieces of rope are unavoidable reminders of another favorite Bak reference, the Binding of Isaac, with its ending of God's promise to Abraham to multiply the people of Israel "as the stars in the heaven and the sands on the shores of the sea." But the hint of blood on the

lip of the goblet that dominates the center of the painting—its main character, so to speak, suspended perilously in space—as well as the twin wreathes of smoke floating upward in the distance, evoke a different Jewish journey with a less happy ending, which leaves us in a quandary. Finally, the wooden slats in the shape of the Hebrew letters *vov* and *gimel*, V and G, couriers from the destroyed Vilna Ghetto, draw us to the memory of a sinister event which neither divine pledge nor artistic tradition can adequately encompass. So which narrative shall we follow, and what are the consequences of the one we choose? It is a dilemma that afflicts the artist as well as his audience.

One question raised by this painting is whether we want more or less of such imagery, much of it borrowed from the peaceful still-life ritual of an earlier era. The ordinary viewer may respond with dismay to the apparent confusion that seems to dominate its composition. Merely looking at a painting is not a very rewarding experience. Seeing into its content in quest of insight is an entirely different matter. The clearest explanation of the distinction between the two that I have ever encountered comes from the photographer Grant Scott, and it is worth quoting in its entirety:

~

There is I believe a seriousness of intention that one
of these words
[seeing] suggests, while the other [looking] gives the
impression of a casual
approach to perhaps what is the same thing.
For example, if I say that
"I see you!" I am suggesting a multitude of
possibilities of what I am
actually seeing. Am I seeing you or who you are?
Or both? Am I
identifying you or merely informing you that you
have been identified?
The word 'see' suggests a depth of visual engagement
that allows the person

'seeing' to control the action and retain control of
any further action that
may take place after the initial seeing. To look
suggests an observation of
surface, it does not suggest any further depth than
that. To look suggests
both the beginning and end of the action, whereas to
see suggests the
beginning of a process of investigation.

~

Who, for example, are the three human figures in *More or Less*, and why are they intruding on a modern version of the still-life tradition that has never included them? Are the two men in the background waving canvases to declare the important role that artistic representation plays in our understanding of human experience? And is the seated figure to the right with what may be a fresh canvas in his lap searching for new ways to salvage some order, and even some beauty, from the disarray behind his back that nearly obscures his presence in the scene? Questions pile up, and members of Bak's audience committed to "looking" are tasked to "see" responses to these sentinels of history and myth that stand vigil before them.

The complexity of such a challenge is vividly portrayed in *Verbal Repair* (BK2665), since any speech that may emerge issues from a damaged world and a damaged self. Clearly art is not immune to thought. There is something grim and even bizarre about this portrait, but its title prevents it from being a mere reflection of human doom. If we are to find a fresh path for *tikkun olam*, the repair of the world, it will not come from a repetition of pious sentiments like the title of a recent Holocaust dramatic piece called *Let There be Light: Stories of Hope and Humanity to Illuminate the Darkness*. The resources of the spirit are simply not visible in the pained and bloodstained visage of this physically assaulted creature, who nonetheless bears the responsibility of finding ways to improve the human condition.

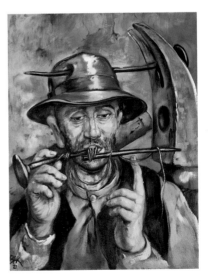

VERBAL REPAIR

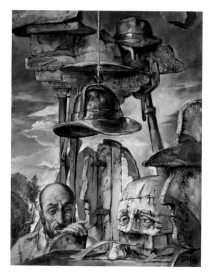

THE MAN MAKES THE HAT (OCTET 3/8)

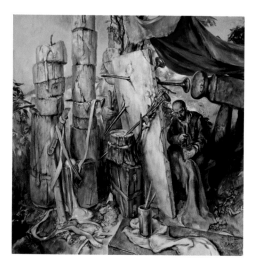

BRUSHWORK

This portrait, however, is only the beginning of a visual journey that winds through the works of *Figuring Out*. It represents one version of an injured self seeking an answer to the question "Who Am I?" in a world whose legacy of violence is now a permanent burden that one must endure. In a cluster of eight paintings that Bak groups under the identical title of *The Man Makes the Hat (Octet)* he offers us various versions of the human face, including actual flesh, stone, wooden profile and a gigantic monument that is sinking slowly into the earth. The peculiar inversion in the group title shifts the problem of identity from social custom—"The hat makes the man"—to the private individual. *The Man Makes the Hat (Octet 3/8)* (BK2633) dramatizes a few of the options but only complicates the problem of locating a comfortable definition of self on our troubled world.

Can art help? In *Brushwork* (BK2710) the artist enters his own landscape, seated between icons of violence at his rear and emblems of past memories before him, separated by a giant canvas whose images we are only left to imagine. But a careful inspection of what we can see illustrates how speech interacts with imagery to enlighten the curious mind. As a hammer and nails impale the surface of the framed canvas, the objects before it seek to preserve the integrity of its brushstrokes. As tenants of remembrance, an informed audience will recall the role that suitcases once played in the journey of the Jewish people to an unpromising destination, just as the broken stone pillars evoke the vital candles that once paid tribute to the memory of the dead. They no longer shed their light or warmth on the human scene. The words of writer Milan Kundera testify to the power of language to interpret the silent tensions inherent in a painting like *Brushwork*: "What terrifies most about death is not the loss of the future but the loss of the past. In fact, the act of forgetting is a form of death always present within life."

Figuring Out presents us with human figures (like the artist in *Brushwork*) who are trying to figure out their identity in the postwar world of the present while simultaneously inviting their audience to understand what their dilemma might

mean for the future of mankind. Is it possible to re-ignite the candles of memory in order to avoid the forgetting that will be a form of death? The philosopher Marcus Aurelius would have answered this question with a resounding "No!" According to this Roman Stoic, "All of us are creatures of a day, the remember and the remembered alike. All is ephemeral, both memory and the objects of memory. The time is at hand when you will have forgotten everything." Fortunately for us, the artist in Bak responds to the same question with a resounding "Yes." Seemingly inconsequential details in some of these paintings are deliberately designed to prod memory into resisting the temptations of historical amnesia. This is especially true of three works linked by similar imagery, though many and perhaps most contemporary viewers will have difficulty relating the visual reference to events of an earlier era.

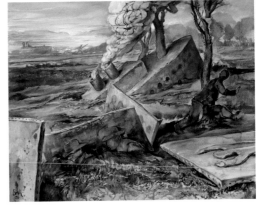

IN SEARCH OF A PORT

The half-finished canvases scattered across the foreground of *In Search of a Port* (BK2693) introduce a recurrent theme in *Figuring Out* of how artistic representation strives to confront some of the urgent episodes in the history of our time, in this case a Holocaust moment that will become clear only through association with two of its fellow canvases. Here we see only a ship sinking into the earth instead of the sea, a misplaced destiny from which a barely intact human figure is hoping to flee.

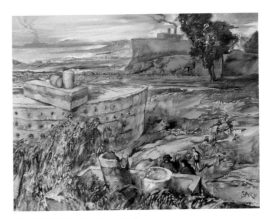

IN THE PARK OF ST. LOUIS

The specific references in the titles of *In the Park of St. Louis* (BK2679) and *Off the St. Louis* (BK2717) shed light on the only seemingly cryptic allusions of these works. In May 1939 a German steamship named the S.S. St. Louis sailed from Hamburg to Cuba carrying 937 passengers, most of them Jewish families seeking refuge abroad. Although only a handful had visas, they believed the Cuban government had promised them transit landing permits while they awaited actual visas from the United States. But when the ship arrived, most of the passengers learned that the Cuban government had canceled their landing

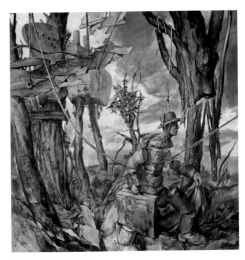

OFF THE ST. LOUIS

permits. Efforts to negotiate temporary permits from the American government failed, and the St. Louis became a rogue vessel in search of a friendly harbor. It found none, and eventually was forced to return to Europe, where passengers were divided into groups that disembarked in Great Britain, France, Belgium, or the Netherlands. By war's end, 254 of them had been murdered by the Germans. *In Search of a Port* offers a visual prophecy of their fate. By refusing to acknowledge their threatened condition, Cuba, the United States (and eventually Canada) virtually denied their right to existence. *Off the St. Louis* provides a stark vision of the result of this denial. Its doomed voyager is a dramatic example of the dismembered self, disintegrating before our eyes, as he struggles to remain intact in a hostile landscape.

A companion work like *Study for a Cancelled Departure* (BK2655) expands the focus of the theme to a global scope, as hordes of erstwhile passengers are left to discover that they are now on a journey from somewhere to nowhere, fleeing threatened violence or inhumane living conditions but finding little empathy for their plight. In addition to its Holocaust reference, are we to see in the fate of the St. Louis a distant harbinger of things to come? Who can deny today that the refugee problem is more than a mere legacy from an earlier time?

Is not this the thrust of *Present Past* (BK2689), in which a refugee leans against his battered suitcase while meditating on the fate of his ghostly predecessors, who are slowly drifting into invisibility? But Bak is an artist who is committed to a world view of multiple perspectives, and *Past Ever Present* (BK2704) offers us an alternative point of view. One can meditate on the crimes of the past from the vantage point of the present as memory grows dim and slowly fades away, or one can immerse oneself, as here, in substantial physical evidence of ghetto ruins and reflect on the murder of their former inhabitants, seeking a key to their destruction. A small human figure is pointing upward, but whether he is questioning (or accusing) divine silence or merely observing nature's indifference we can never

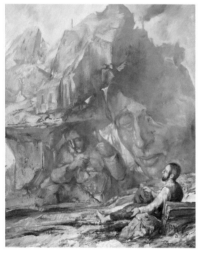

STUDY FOR A CANCELLED DEPARTURE

PRESENT PAST

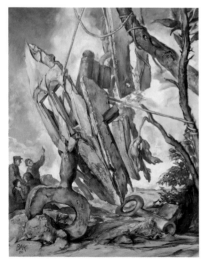

PAST EVER PRESENT

know for certain. Nearby an adult seems to be addressing a child, but again we are left to wonder whether he is offering a key to the meaning of this catastrophe or simply announcing its absence.

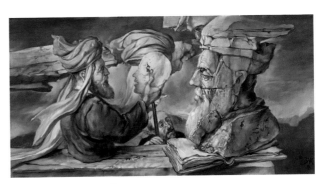

INTERMINABLE DEBATE

All the questions asked by these paintings may not have specific answers, but they provoke speculation. Bak finds a language for this line of inquiry in the title of *Interminable Debate* (BK2699). That naked skull was once a human creature, but it greets the living sage that grasps it only with silence. This work belongs to the archeology of art: "if you could speak," the sage might be asking, "what could you tell me about your reason for being and the nature of your fate?" And the one contemporary figure in this landscape of silence also appears to be pleading with the monumental image of a long-gone learned sage to unlock the wisdom of his years. We are beholding a mute autopsy of the human journey, invited to become artists of the imagination ourselves as the only way of joining this arduous excursion into the meaning of our current existence.

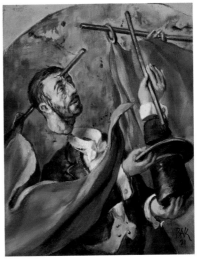

THE POSSIBILITY OF THE IMPOSSIBLE

It is a painful and perilous journey as well, not designed for the weak of spirit. When the children of Israel grew up to become adults of the Holocaust, the story of their scriptural origins had to be expanded to include the violent exploits of modernity. Careful observers will note that the artist does not even spare himself, since an artist often turns up among Bak's cast of characters in *Figuring Out*. But the most unusual member of this cast, new to Bak's dramas of identity, is the figure of the magician, and Bak's attitude toward this master of manipulation drifts between the whimsical and the grim, as if to offer us a dual menu of possibilities when approaching such an entertainer.

The very title of *The Possibility of the Impossible* (BK2676) hints at the tension between the two. Magicians were once known for pulling rabbits out of hats, but this one seems to be a victim of his own tricks, impaled by the wand that once mesmerized his audience. We are staring at the portrait of another dismembered self, amputated, beheaded, having lost control of its own destiny,

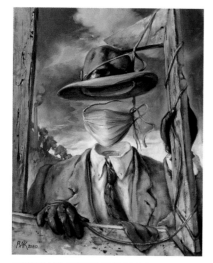

PORTRAIT OF THE INVISIBLE

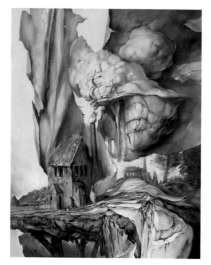

IN SEARCH OF THE KEY

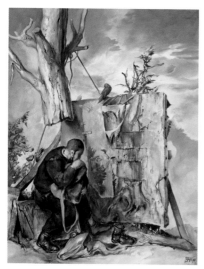

PAINTED

assaulted by an invisible force that no one could have predicted. How many times in our century have we lived through a dismal period when the impossible became possible?

Art mirrors a reality external to our selves, but on occasion it can prompt us to search within, to reflect on the metaphorical meaning of the kind of dismemberment we have just examined. When nature and history conspire to deprive us of our sense of being human, what remains? Future generations may look back on *Portrait of the Invisible* (BK2688) to admire how Bak has captured the essence of our Covid-19 pandemic, focusing chiefly on a mask that screens a face effaced. And indeed, that now universal article has created a form of common anonymity that no one could have predicted. But by confronting us with our own image when our identity has been erased by forces we do not yet understand, we are compelled to ask what needs to be done to reaffirm our sense of the human. A portrait of visual absence provokes a response of mental presence, but the content of that "presence" remains to be explored.

This is part of the adventure of "seeing" that Bak's art inspires. One option is to admit that the violent events of history can so reduce the capacity for human response that the result is a diminished self hardly able to find a role amidst memory's landscapes of atrocity. This seems to be one reaction to the barely visible figure of *In Search of the Key* (BK2703). The icons of a crematorium chimney and a dwelling empty of residents backed by a nearly canceled sky leave little hope for a rebuilt future. Where is the promise for a life that hovers at the edge of a precipice propped up by a few unstable timbers?

But another option is to remember that artistic representation is not equivalent to reality, but only an aesthetic version of it, a truth affirmed by *Painted* (BK2706) in which a substantial human figure vaguely reminiscent of Rodin's *The Thinker* ponders the value of a chaotic canvas that also teeters on the edge of a mountain. Who is the skeptic here, the artist or the viewer? Is art an allusion to a reality beyond itself, or an illusion that it represents a reality existing only within the frames that hold its canvases?

Or is it simply one of many tools to aid us in appreciating the problem of finding unity amidst the disarrays of modern civilization. This appears to be a central concern of *Debate, Unending* (BK2712), across whose surface are strewn the hammers and nails that occupy space in so many of the paintings in *Figuring Out*. If the meaning is in the metaphor, viewers cannot avoid joining the debate, thus becoming part of the artistic process themselves. The verticals and horizontals that dominate the visual design of this painting drive the eye in two directions at once, while the scattered hammers and nails add to the confusion: obviously something has to be rebuilt, but what? And where? And by whom? The rickety archway in the foreground invites us to join in the inquiry. Is that arc void of color intended to suggest the need for a new rainbow promise more fitting for our modern generation? Are those three men figuring out how to build a better ark for the future? They have the tools, so the meaning remains in the metaphor.

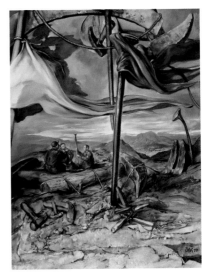

DEBATE, UNENDING

When we meet them again in *Suspended for Now* (BK2714), both the metaphor and the topic under discussion have changed. Our three friends have a more urgent matter to discuss now as the arc above has turned into a military image in the shape of a rocket or missile, at least for the viewer, a threat from the world of modernity that hovers over their conversation. Is this a warning or a prediction of the hazard mankind must face as it undertakes the process of building a better future? Any visual reference to spiritual promise like the one offered to Noah has faded from memory in the presence of this new menace to the human landscape. But in these paintings, so many of which seem to address each other, "figuring out" is an ongoing and perhaps an endless test.

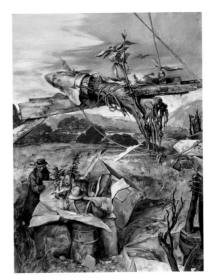

SUSPENDED FOR NOW

As past and present continue to intrude on each other, an alarming trend emerges, as we see in *Jacob's Latest* (BK2716), in which modern technology cancels traditional means of launching contact with the divine. Is Jacob now supposed to express his longing for spiritual intimacy through text messages to God on his laptop? The distress in his expression prevents us from seeing this as a mere parody of a current religious crisis. The story of Jacob's dream from holy scripture has disappeared

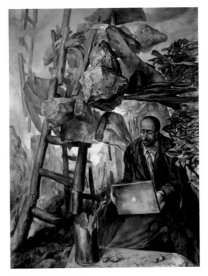

JACOB'S LATEST

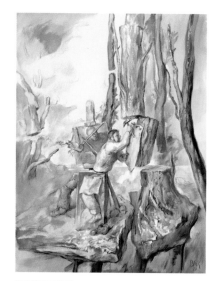

REPAIRMEN

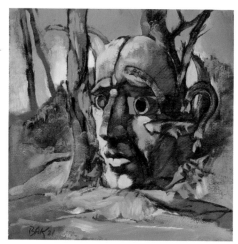

LOOKING FORWARD

from view—and perhaps even from memory. Nonetheless the journey through this series continues to shift from a vision of limited despair to one of limited opportunity.

As if to stress the need for a fresh approach to the modern dilemma, in *Repairmen* (BK2725) the artist moves from oil on canvas to a more fragile mixed media presentation on paper. The portrait on the easel is x-ed out, as if to say: "Only use my art to draw your attention to the world around you." And this is exactly what the half-formed human figure in *Repairmen* is doing, angrily affixing a declaration of intent to a fragment of the exploding landscape that surrounds him. In a post-World War I poem called "The Second Coming" (1919) William Butler Yeats described for his generation a society in which "Things fall apart," where "the center will not hold" and "Mere anarchy is loosed upon the world." He had no idea how prophetic his language would sound to the generation of a century later: "The blood-dimmed tide is loosed, and everywhere/The ceremony of innocence is drowned." The Christian reference of Yeats's title is ironic, since no Redeemer has appeared on the horizon, then or now. But Bak is not content to settle for the poet's horrific image of a "rough beast" that "Slouches towards Bethlehem to be born." *Repairmen* represents a modest effort to celebrate a human agency that might slow its approach and restore some of the lost innocence that Yeats's beast is determined to banish forever. Is not this what those eternal exiles and wanderers in these paintings, Adam and Eve, are striving for too?

Yet lest we grow careless in pursuing the impulse to repair, Bak introduces his own version of Yeats's "rough beast," an alarming portrait called (ironically) *Looking Forward* (BK2719). Where would its gaze toward the future misdirect us? Whether we name it a demon from nature or a devil in disguise—I prefer the label "Technology Man"—for me it represents the most frightening engagement with faces in the entire repertoire of *Figuring Out*. Its question-mark ear makes us wonder whether it would be capable of hearing pleas for a more human future. Does its seemingly telescopic vision conceal a mechanical blindness that is capable of "looking forward" but seeing nothing?

Our own gaze must be directed elsewhere, as we muse on the problem of reconfiguring the human and natural disfigurement that spreads its perils across Bak's visual universe. The solitary, immobile robotic creature of *Looking Forward* seems drained of energy when compared with the dynamic vigor dramatized in *Helpers* (BK2654) in which the collaborative effort of human figures resolutely drags with them wooden cutouts from a wounded past, in their determined journey toward an uncertain future.

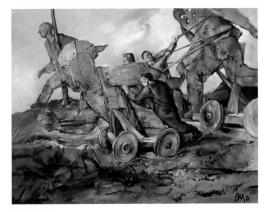

HELPERS

A parallel impact is conveyed by *The Other Repairmen* (BK2680), who have moved beyond debate to a different kind of pursuit—understanding the instruments of assault that have disfigured their environment. The rare vista of a serene landscape, the absence of frenzied activity and the presence of totally integrated human figures create a mood of tranquility that calms not only the scene before us, but the mind and imagination of the viewer as well, who is encouraged to penetrate their visual milieu.

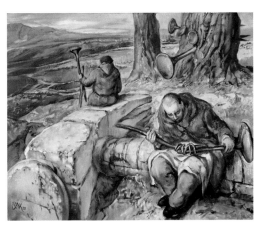

THE OTHER REPAIRMEN

These "repairmen" are extracting from a victimized tree trunk the devices of violence that threaten its continued existence. And the figure in the foreground is studying their mechanism, hoping to find ways of redesigning them, as the workman here is trying to do, so that they may serve a more fruitful end. But further imagery in this work suggests that his task is more complex than he yet realizes. He and his companion, like some of their predecessors, are still part of the archeology of art, and their excavations in search of meaning have only begun: they have not yet fully appreciated that they are unwittingly resting on the real source of power, the gigantic stone hammer, without which the nails would lack the capacity to cause injury. Although like the stone candles we have already examined, its original vitality may belong to the past, a "seeing" audience can restore voice to the silent artistic representation of its destructive energy.

But this very process, promising as it sounds, raises a new concern, one which requires a "figuring out" of its own. Once we admit and begin to understand the damage that violence

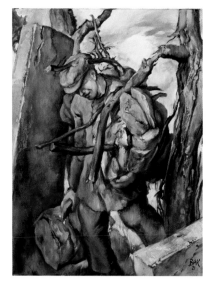

DETACHMENT ISSUE

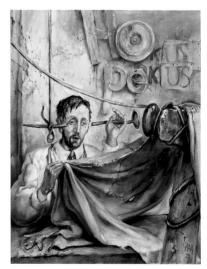

ENDURING, A

has caused to our civilization—and certainly this is not a problem that we commit only to the past—our investigation has also only begun. Suppose the traveler in *Detachment Issue* (BK2650) had journeyed with us through the disturbing landscapes of *Figuring Out*. Fragments of nature have literally pierced his physical being, but how do we translate these metaphors into memories? What philosophical and psychological burdens does he bear with him, and how can we share their effects? How does he escape them—or rather, how will he learn to endure them? His experience may be transitory, but the art that represents it is permanent, and its severity forbids us from dismissing it merely as a form of visual entertainment.

A vital clue to our inquiry appears in *Enduring, A* (BK2683), one of the most intriguing and significant works in the entire series. After viewing an array of eroded faces, defaced or made invisible by masks, blindfolds, bandages or other distortions, it must come as some relief to gaze on the countenance of a normal human being who is free to engage with a revelation that has transformed not only his expression, but his very demeanor as a living creature. The cunning artist refuses to give us a glimpse of what he has seen, but it has granted him an insight that permits him to remove the nail that has injured so many of his fellow mortals and allows him to contain the threat of the giant hammer that has emerged from its archaeological immobility and entered the realm of real experience. Ropes now restrain those instruments of destruction, the nail and the hammer, and the man himself seems to be in the process of "figuring out" how to repair the blood-stained material that he holds gingerly in one hand. Has some recognition enabled him to endure an injury from the past while resuming a human identity in the present?

Behind him on the wall hang the letters of the magician's mantra, "hokus pokus," but he either ignores these tokens of deception or is unaware of their existence. They cannot be allowed to interfere with his personal journey toward insight. But we are unable to follow suit, and are left to wonder whether those letters contain a message whose meaning the viewer is required to decipher. Those carefully inscribed letters for the

word "us" represent an appeal and a reminder to Bak's audience that the encounter with art is an act of participation uniting the seer with the seen in a mental as well as a visual intimacy.

It should come as no surprise then that *Enduring, B* (BK2684), a companion to its predecessor, should turn its intention away from itself and toward its audience, literally inviting us to become artists of the imagination ourselves. The question of "Who am I?" is thus also a question of "Who are we?" With a friendly gesture an amiable host raises a veil from one last "effaced face," but this time it is only covered, not disfigured. The task of sculpting its identity and thereby restoring its human features remains our own.

~

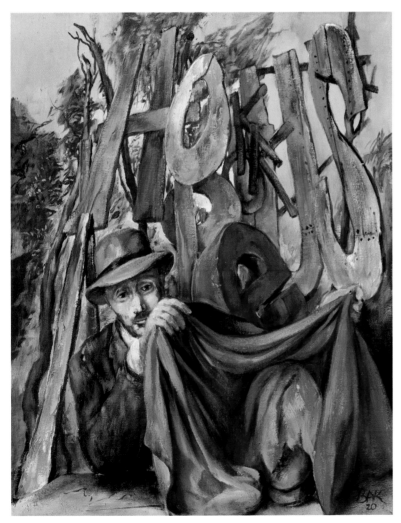

ENDURING, B ~ 2020
Oil on canvas
20 x 16″
BK2684

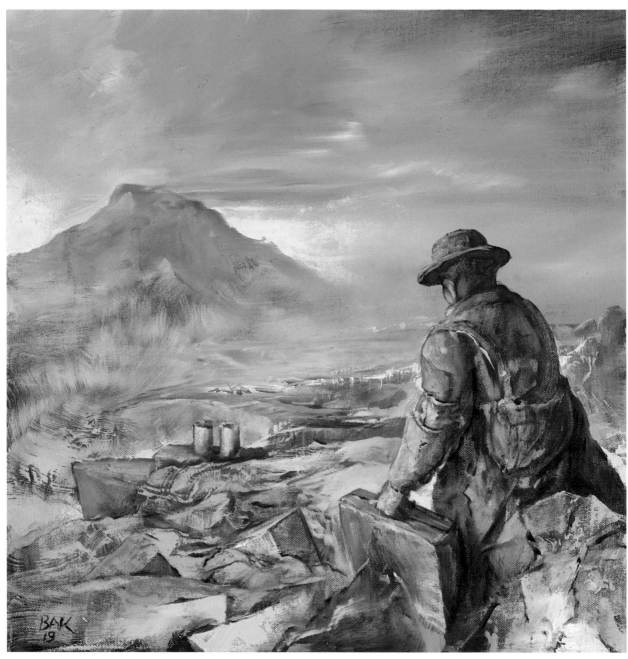

CONTINUOUS JOURNEY ~ 2019
Oil on canvas
20 x 20"
BK2581

GO FIGURE

by ANDREW MEYERS

~

~ STEPPING INTO BAK'S MIND ~

A compact, sturdy figure stands at the doorway of a modern home in a leafy Boston suburb. Samuel Bak waves us into the lofty, well-lighted postwar addition to his pastoral home. The original house, built in 1900, was an outbuilding on the local estate, and the rough, rustic stone wall that we passed on our way in, evocative of the sublime outcroppings in Bak's own work, dates to that time. If "Bak" is a towering figure in art, wrestling with some of the most challenging and ambitious questions, the "Sam" who entertains us in his uncluttered foyer is approachable, warm, funny, a gracious host, full of wonderful, and sometimes shattering, tales.

We have come to visit, to learn, and to see Bak's most recent works, as he prepares for the Pucker Gallery exhibition, *Figuring Out*. There are, of course, beautiful figures in Bak's home, some of them by his own hand, others part of his well-curated collection of artifacts and the work of other artists. They populate a historical, personal, and imaginary landscape, weaving in and out of a life story that includes in its reach both unthinkable tragedy and glorious triumph. As Sam walks us through this landscape, both literal and figurative, his deep intellect and lively wit guide us lovingly, and provocatively, through a narrative that traverses some of the most devastating events of the past century.

Walking through Sam's home, especially once inside Bak's studio, is to journey through a mind that is working to "figure out" so much: How do we navigate incomprehensible tragedy? How do we reconcile faith and horror? Where is there space for kindness and grace in a broken world? How can intellect, humor, and love heal a world wracked by greed, violence, and

hate? How can art help us build order out of chaos? We ascend a staircase into Sam's studio, where his newest work, alongside some canvases he has worked on for decades, greet us with a constellation of figures eager to engage with us.

The artist "Bak's" mind and hand are shaped by the individual "Sam's" remarkable journey. Samuel Bak was born in Vilna in 1933 into a bourgeois, artistic family. When he was 8 years old, the Germans occupied Vilna, and Sam was charged with preparing the yellow badges they were compelled to wear as Jews. Sam's father was sent to a labor camp and eventually shot to death. Sam and his mother escaped the Vilna Ghetto to his great aunt, Janina, who found the mother and child haven in the local Benedictine convent. A nun provided the already artistic Sam with painting supplies. Before war's end, Sam would see a return to the ghetto, internment in a forced labor camp, escape, liberation, and his father's death, days before Vilna's liberation. Sam's remarkable journey over the next few years would take him from a displaced persons camp, through art studies in Lodz and Munich, to recognition as a prodigy at the age of 14, when an exhibition of Bak's work was organized in honor of David Ben-Gurion's visit to Germany.

Bak's mature style, a symbolic representationalism, or allegorical realism, if you will, emerged in the 1960s, after his first show in Rome in 1959, as the young Bak re-evaluated the capacity of abstraction to address complex human issues. Over the course of his peripatetic studies—at the Blocherer School in Munich (1945), the Bezalel Art School in Jerusalem (1948), and the École des Beaux Arts (1956)—he had already been exposed to, and mastered, Realism, Cubism, Surrealism, and the rigors of Beaux-Arts Classicism. But in the 60s and 70s he turned to what Bernard Pucker has called "a metaphysical figurative means of expression," developing a rich and multivalent symbolic vocabulary that Bak continues to plumb to the present day.

In this context, Bak's turn from abstraction to representation and figuration in his mature style is a declaration that art must grapple with the complexities of both individual suffering and the tragedies of modern history, a world in which the

Holocaust, the dropping of the atomic bomb and later cataclysms are possible, yet also a world which allows for repair and redemption. Re-deploying the pre-modern tropes of the still life, landscape, and figure permitted Bak to develop the complex language of symbols and metaphors requisite to at least ask the difficult questions, and to use storytelling to tell uncomfortable truths. In this personal but accessible visual grammar, the figure is where Bak thrashes out the thorny questions of personal suffering and agency, and, ultimately, presents a hopeful vision for hope and healing.

~ FIGURE IN OR OUT? ~

Over the course of Bak's early life, modern movements in art had served to sever the connection between art and the figure. Once a primary subject of painting, from 1st century Roman fresco to the aristocratic portraits of Jean-Louis David, the (ostensibly) realistic portrayal of the human figure fell into disrepute as the photograph captured the pole position in documentary representation, and Modernist explorations of the nature of paint as a medium, the subjective experience of the painter, and the power of abstraction, made the representational figure passé.

But Bak sits in calculated contrapposto to this anti-figural narrative. Even as Bak navigated the currents of modernism, studying with and learning from some of the masters of pre- and postwar abstraction, in the end he was not willing to relinquish the clarifying and integrating power of representation and the figure. We see in his evolution a synthetic interplay between the real and abstract, between the empirical and the ideal, between the historical and imagined. And in his current work he deploys the figure across this spectrum, from the integrated representational figure as subject to the deconstructed figure as object, and all the rich permutations in-between. Bak's figures are a synecdoche for his complex ambition to use painting to narrate and navigate his experience and his understanding of the world, and to argue for the possibility for healing a broken world, for *tikkun olam,* in the Jewish tradition. The figure, whole, broken, and recomposed, is the locus for the uncertain potential for re-membering and redemption.

In his most recent work, Samuel Bak deploys the figure in at least three modalities: the integrated subject, the dis-integrated object, and, in a few works, the subject and object re-united. Of course, this taxonomic triad, constructed for the purpose of our discussion, simplifies what is really a nuanced continuum of figural strategies that reveals deeper intentions in Bak's work.

~ THE FIGURE AS SUBJECT– INTEGRATED "SAM" ~

In the first mode, "figure as subject," the figure is integrated and organically whole, and is ostensibly or partially autobiographical. The figure is "Sam" as the subject, or parts of Sam, representing aspects of his lived experience. In these works, the figure is made of flesh and blood, is whole, and often carries the visage that the artist has deployed in the past to represent a version of himself. To call these images autobiographical is to oversimplify, as all Bak's works hold elements of his personal history while at the same time transcending the personal. But these figures are the closest we will find to the presentation of a "Sam" as an explicit and recognizable subject, capable of choice and historical agency.

That is not to say that this family of images, of figural subjects, is straightforwardly representational. Bak manipulates color, scale, texture to unsettle our sense of the "normal," to manifest a world broken and uncanny. But the human figure in these works is whole and has integrity. This is the individual IN history, if not always fully OF it, a being with a sense of self and purpose, even if their agency is constrained and compromised by their surroundings. We will look at three types of figural subjects in Bak's recent work: the traveler, the artist, and the magician.

~ THE TRAVELER ~

We encounter eight human travelers in the works *Continuous Journey* (BK2581), *Adam and Eve and Their Resettlement* (BK2711), and *Key-Power* (BK2700). While the worlds through which they pass may be broken, the travelers themselves are whole. This condition does not obtain in the pre-

CONTINUOUS JOURNEY

ponderance of Bak's more recent figural works, so it merits some attention. In the fragmented world of Bak, achieving a coherent and unbroken form is no mean feat. And not only are these figures whole, but they are also in motion, moving with varying degrees of purpose through their often less-than-encouraging landscapes. These figures are individuals in history, with a palpable sense of purpose (if not always clear objectives), even as their environments may suffer from the tragedies and ambiguities of modernity.

Through sheer force of will the stony figure in *Continuous Journey* struggles to emerge from his rocky environment, pulling away from a past, offstage right, and toward a future represented by a landlocked ship and an ominous mountain. While he is in a similar palette as his surroundings, he is clearly distinct and emergent, if not fully independent. Unlike some figures we shall see later, he is whole and coherent as a form. While so many of Bak's figures are dismembered and deconstructed, this version of the figure gives us a sense of unity, integrity, and individuality, despite his stony palette, which threatens to absorb him back into the landscape. Indeed, if you look closely, our protagonist is more colorful than the surroundings out of which he emerges, struggling for humanity and life. And he struggles toward a clear goal: a ship.

The ship recurs in Bak's world in many guises: Sometimes as the ark of Noah, the hope for mankind after the cataclysm of the flood, representing the safe haven of Mount Ararat, escape, redemption, and a new beginning. During World War II, the escape from the countries controlled by the Nazis took place on steamships, modern arks, such as the one depicted here. But this ship is landlocked, its palette fused with its surroundings, and its funnels are quiet. For many of those seeking to escape, these ships were out of reach, and for others, such as those on the S.S. St. Louis, turned away from Cuba, the US and Canada, the ship proved insufficient in the face of nativism and politics. The ark has no real hope of coming to rest upon its Ararat in the painting, a mountain sitting tantalizingly close in the background. And the ship is, after all, also the technology of 20th century

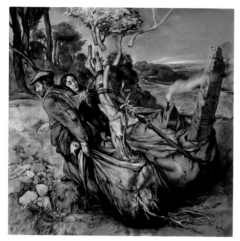

ADAM AND EVE AND THEIR RESETTLEMENT

industrialization, the modern machines that produced the tragedy of World War II, turning the efficiencies of industrialization toward the mass production of death. But our figure, with whom we identify, pushes on, suitcase (or is it a portable easel?) in hand, despite all these uncertainties.

Adam and Eve and Their Resettlement finds us gazing down upon two struggling figures, dispossessed, pulling with them their home (complete with still smoking hearth) and a tree, despite the weight of a stone pier (the literal weight of history?). Our angle—not unlike those of the Realists such as Millet and Courbet—is from slightly above; we are engaged but removed, sympathetic but not fully empathetic. But the figures are unaffected by our disregard; they struggle onward in the face of Herculean burdens and fragmented hopes.

Once again, the figures are whole (if patched) and empathetically portrayed, with determined expressions. The man pulls a sack holding a tree that still lives, despite being uprooted and having severed branches. In this sense, the tree is also a figure, belonging to the category of dismembered figures we will soon discuss. The tree is a frequent symbol in Bak's oeuvre. Here it may be the broken figure, holding on to life despite being uprooted and cut, or a descendant of that original Edenic Tree of Knowledge, our protagonist schlepping the weight of original sin, with the broken branches signifying the limitations of knowledge as a tool in fighting destruction and loss. Finally, what of the diminutive house in the woman's sack? The hearth burns on, as evidenced by the smoking chimney, but the chimney has a dual connotation: hearth and crematorium. So do our figures carry with them the fortifying memory of home, the tragedy of its loss, or the trauma of the camps? All we know for sure is that they carry, struggle, and persevere.

In *Key-Power* we see Bak's irony and humor in full flower, as a band of Lilliputian figures, all whole and intact but overwhelmed by hypertrophic keys and signposts, argue over the

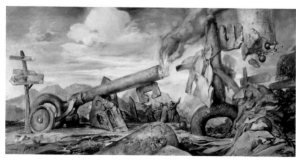

KEY-POWER

course to take through a barren scaleless landscape. Here, although the figures are complete and active, they struggle to decide upon a direction, looking to confusing signposts and illegible clues. While figuration, here, still bestows agency upon this band of travelers, Bak's use of scale has undermined their ability to exercise that agency. The keys, traditionally a tool for opening and unlocking, symbols of knowledge and awakening, are unavailable to the figures for three reasons: the keys have been coopted into other uses, they are too large to be of use, and their scale has rendered them unrecognizable to our travelers. And to what uses have the keys been turned? They are smokestacks and canons (resting on a subsiding house/synagogue, no less), twisted from their positive purposes of egress and enlightenment to those of destruction and death. But the human figures argue blithely along, as humans are wont to do, trying haplessly, if not hopelessly, to decipher the signs. But they are undaunted, and the possibility that they will find the keys, while remote, remains.

~ THE PAINTER ~

Perhaps the most tantalizingly autobiographical figure is the painter. He appears regularly in Bak's work, often with a visage that Bak has used to represent a version of himself, although it is not fully a self-portrait. It is too easy, and inaccurate, to look for concrete autobiography in Bak's work. While his life story plays a significant role in inspiring his concerns, his narratives are universal and directed outward, not inward. But in the various versions of the integrated figure, we do see multiple representations of a painter, and that painter is clearly an alter-ego for "Sam," wrestling with the limitations of art, and constraints of his own past, to explain, resolve, and create wholeness out of what has been broken.

In *Stop Over* (BK2622), we find the painter in a bucolic Leonardo-esque landscape, with his portable plein air easel. In a mordant meta-fictional turn, Bak, the real artist, has painted "Sam," the imagined "artist" carrying his tools to a secluded hillside spot, where he has either found, or constructed, an uncon-

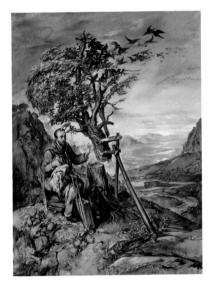

STOP OVER

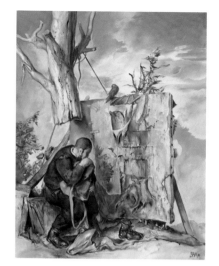

PAINTED

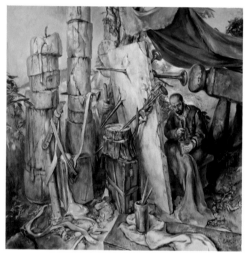

BRUSHWORK

vincing splint for another broken tree. The repair is provisional at best, ready to tip over under the tree's own weight at any moment. The painter sits in its inevitable path of destruction, holding up his hand as a preventative measure. Is this enough? In a Newtonian reality, certainly not. But in Bak's world, we feel the possibility that the painter's gesture may be sufficient to slow down the tree's collapse long enough for him to open his easel and paint his/our way out of the impending tragedy, to paint the world back to wholeness. And perhaps the birds, signifiers of redemption, flying onto the branches will help by using their wings to lift the tree long enough for the painter to work his magic. Or will they help to topple the precarious treetop by landing upon it? Can art make up for where the Tree of Knowledge has failed, or where we failed God? Can painting repair the world? *Stop Over* raises these questions.

Painted (BK2706) and *Brushwork* (BK2710) offer responses to some of the questions that *Stop Over* raises. These figures argue that we do not know for sure, but that the joy and responsibility of art is to try. In *Painted*, the artist works to reconstruct the trunk and roots of the tree (knowledge, connection to the Genesis God, family roots, life, growth). The bird is back as a symbol of redemption and rebirth (Noah's dove) and, giving us some degree of hope, a live tree grows behind the canvas.

In *Brushwork* the frequent trope of the nail appears, with its association with Jesus, sacrificing for our sins and suffering. A nail is usually hit, but Bak's nails are also actors and have agency of their own, often connecting and supporting. The nail is a multivalent symbol, as it can both join and pierce. In *Brushwork* it does both, re-assembling a dismembered tree trunk and piercing the painter's canvas (twice). The hammer driving the nails, in color, scale, and position, is an analogue for the painter sitting next to it—the painter has power and agency equal to that of the hammer, his brush (also a wand) the analogue of a nail. And, of course, nails can build houses and other structures. Indeed, the signs and signposts in the other images in this essay are all held together by nails.

But, due to Bak's manipulation of scale, the nail is also reminiscent of a trumpet, with all the accompanying biblical associations. In Judges, Gideon uses trumpets to help the Israelites overcome overwhelming odds in a battle against the Midianites, and in the book of Revelation, seven trumpets sound the coming of the apocalypse. And, if the New Testament is your preference, not only do the nails recall the sacrifice of Jesus Christ, but the nails piercing the painter's canvas form a cross. So, the nail may represent the suffering of the artist, the potential for rebirth, the ability to prevail against bad odds, and the anticipation of the coming of the messiah.

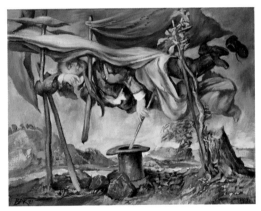

ENDURING, A

~ THE MAGICIAN ~

The final "figure as subject" is that of the magician. We have already seen the wand appear as paired with the paintbrush, but in the figures in *Enduring, A* (BK2683) and *A Magicians Rest* (BK2668) we see the artist as an actual magician. In *Enduring, A* we find a version of Sam, preparing for his "magic act," with the assistance of a hammer and nail, and the phrase "Hokus Pokus" [sic], in cutouts and other fragments, on the wall. Of course, "hocus pocus" is a nonsense phrase used by ma-

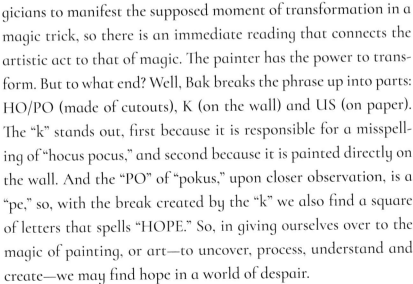

A MAGICIANS REST

gicians to manifest the supposed moment of transformation in a magic trick, so there is an immediate reading that connects the artistic act to that of magic. The painter has the power to transform. But to what end? Well, Bak breaks the phrase up into parts: HO/PO (made of cutouts), K (on the wall) and US (on paper). The "k" stands out, first because it is responsible for a misspelling of "hocus pocus," and second because it is painted directly on the wall. And the "PO" of "pokus," upon closer observation, is a "pe," so, with the break created by the "k" we also find a square of letters that spells "HOPE." So, in giving ourselves over to the magic of painting, or art—to uncover, process, understand and create—we may find hope in a world of despair.

But why is the disruptive letter a "k?" In Hebrew K is *Kaph* and in Semitic languages the letter *kaph* derives from the pictogram of a hand. The meanings of this letter are "bend" and

"curve," from the shape of the palm, as well as to "tame" or "sub-due" as one may do with a firm hand. So, the deployment of the *kaph* as the break in HO-k-US, PO-k-US may suggest that the power of the hand, of the individual artist, can turn "hocus pocus" (magic) into "hope."

~ THE FIGURE AS OBJECT— DECONSTRUCTED "BAK" ~

While the examples above reveal coherent, whole figures who act as subjects in history, many more of Bak's figures are decon-structed, dismembered objects at the mercy of forces beyond their control. While the previous figures were integrated, those below are "dis-integrated," and in their decomposition these fig-ures become more representative of specific ideas or symbols, becoming reconstructed as just another element in a still life or landscape. In their decomposition and re-composition these elements of the figure are transformed, in an artistic form of transubstantiation. They are dis-membered, and therefore be-come subsumed by their environments in ways that the whole figures do not. As a result, these "figures as objects" find them-selves subjected to forces they cannot fully resist and integrated into landscapes from which they struggle to emerge. We will try to figure all of this out by looking at three fragmented figures: the runner, the cutout, and the (now fragmented) painter.

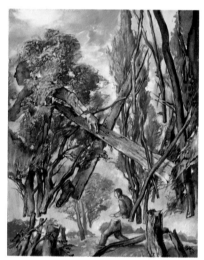

TO THE UNKNOWN

~ THE RUNNER ~

In *To the Unknown* (BK2629) and *Triptych of Inescapable Lot* (BK2647-BK2649), we see the figure destabilized and dis-em-powered through dismemberment and dis-integration. Whereas the previous figures wholeness gave them the capacity for a form of agency, making them subjects of their stories, these figures become objects of forces beyond their control, sometimes even to the point where they are absorbed into the landscape, or become objects in a still life. This disempowerment is most evident in *To the Unknown* where the two runners are either split in two or flattened. Here, there are two runners: one is representational, a recognizable human form, but cut in half at the waist. The

TRIPTYCH OF INESCAPABLE LOT (LEFT)

possibility of re-integration, of wholeness, is nearby, the mere reconnection of two proximate halves. But the second runner is transformed nearly beyond recognition: flattened into two dimensions, tangled up in the trees, with legs transformed into a cross of boards precariously attached to a remaining shoe. We feel the runners' ambitions, their persistence in believing that they can make progress, either away from what they are fleeing or toward their goals, but their absorption into the broken landscape prevents them. Indeed, the composition itself holds them in place: the cross-legs are centered on the canvas, anchoring the flattened runner, and a cut runs through the entire image, bisecting the representational runner just as it does the forest. These figures have less agency than do the "subject figures" discussed in the previous section of the essay, as their dismemberment leaves them prey to the physics of their world.

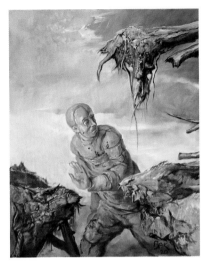

TRIPTYCH OF INESCAPABLE LOT (CENTER)

The *Triptych of Inescapable Lot* presents a similar set of frustrations for the object-figure. We see a male figure, what remains of the "Sam" figure, in various iterations of transformation, his flight frustrated by his dismemberment, transubstantiation or both. Beginning on the right, we find the runner almost whole, but cut at the shoulder and neck, and entwined by the branches of a dismembered tree. The figure has enough integrity remaining to hold out the hope that he might still escape. But moving left in the triptych, the figure has turned to look back and transformed, not into the pillar of salt of biblical fame, but into stone. In this case we wonder upon what, if not Sodom, the runner was gazing when he turned: Was it a traumatic past that froze him in place? The paralysis of loss? Disobedience against God's commands? In the final panel, we find the runner in an array of transformations: petrification, dismemberment, flattening, and disappearance. He/it is absorbed into a stone pier (to which he is bound), dismembered at the right leg (which is absent or invisible), and his left leg is flattened into a cutout (with the coloration of a *tallis*). This poor aspiring escapee must battle a panoply of external forces (or internal pathologies?) arrayed against his/its progress: the petrification of uncertainty, the bondage of memory, the absence of loss, and the insufficiency of faith.

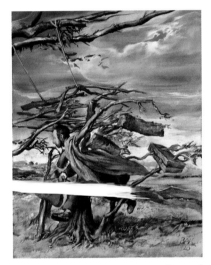

TRIPTYCH OF INESCAPABLE LOT (RIGHT)

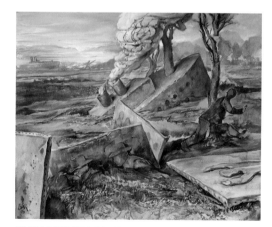

NAILINGS, D (SEPTET 4/7)

FROM LONG AGO

IN SEARCH OF A PORT

~ THE CUTOUT ~

Perhaps the figures most immobilized by fragmentation are the cutouts. Devoid of any hope of integration or wholeness, the cutouts, by virtue of their two-dimensionality, become pictorial elements completely subject to forces beyond their control, to the logic of assemblage, the imperatives of still life or landscape composition. There is a hopelessness to *Nailings, D (Septet 4/7)* (BK2642) as the disembodied figure, grasping a bent nail, attempts to reconstitute a self despite the incapacity of his/its flatness and dismemberment. The figure of *From Long Ago* (BK2618) manages a semblance of unity, but only through a patchwork of nails and branches does he/it recompose. No movement seems possible without disintegration. The cutouts have none of the potential agency of the subject figures but are beholden to chance or fate for the slightest hope of wholeness, a wholeness, based as it is on precarious assemblages, that precludes progress.

~ THE PAINTER—FRAGMENTED ~

Our final object-figure brings us back to the painter. Even as the integrated subject-figure artists we discussed earlier offered a hopeful recognition of the power of art to process, understand, and reconstruct, these deconstructed and transformed painters remind us of the limitations of art to overcome sorrow, pain, and chaos. *In Search of a Port* (BK2693) finds the figure, reduced to a cutout, running/rummaging through a painting strewn landscape, as a steamship sinks into the earth. The painter is absent, their work barely visible, powerless to help the flattened figure find solace in memory or to construct an imagined future through art. This ship, its engines still alight, can provide no escape, as it is pinned to the earth by a tree and sunk in a pit. The fragmented and flattened painter in *Repairman* (BK2725) appears hopelessly outmatched by both his own dismemberment and a fractured landscape. And in *The Art of Underpainting*

(BK2695) the painter, reduced to a head and arms, seems to require all sorts of devices just to stay functional. But even when the painter is so fragmented or constrained there is still hope: a functional steamship is visible on the horizon of *In Search of a Port*, the painter hammers on in *Repairman*, and in *The Art of Underpainting* an unbent nail grows, heroically, and the tree stump offers up new growth.

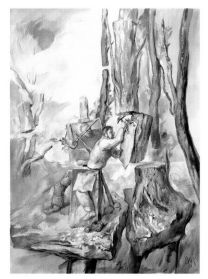

REPAIRMEN

~ GO FIGURE WITH SAM BAK ~

So, we have, in the subject and object figures of Samuel Bak, a complex narrative: On the one hand, the more integrated figures seem to offer the hope of agency and choice, albeit of a qualified and provisional nature, while on the other, the fragmented and transformed figures seem to sink into a less optimistic condition of constraint and paralysis. But, of course, this is an oversimplification. Even as the subject-figures find a path forward, their potential for happiness is tempered by loss, sorrow, and uncertainty; and while the object-figures appear mired in disorder and despair, hope often appears on the horizon.

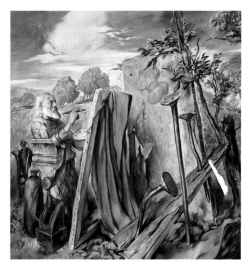

THE ART OF UNDERPAINTING

Bak employs both integrated and dis-integrated figures as a means of understanding an often tragic, complex, and confusing world, and to offer the possibility of remembering and re-constructing. Bak's figuration anchors a complex symbolic and metaphorical language that he deftly deploys as a means of keeping the horror of the world at bay, using the figure to "figure out" how one finds a positive narrative in a world filled with death, despair, and tragedy. In the Jewish tradition, the world is acknowledged as broken, but the individual is expected, indeed commanded, to engage in *tikkun olam*, to repair the world through *mitzvot*, good deeds, and *chesed*, acts of loving kindness. In the work of Samuel Bak, the integrated "Sam" and deconstructed "Bak" chart a provisional path forward through art, with travelers and runners who are not fleeing, but moving with a purpose, imagining a future, reconstructing the broken world through memory, imagination, and creation.

The figure, whole, broken, and recomposed, is the locus for the uncertain potential for remembering and redemption. Bak turned to representation and figuration early in his mature career, after mastering abstraction, because he wanted to tell compelling and usable stories of redemption, to use storytelling as an ameliorative and constructing project, to heal the world.

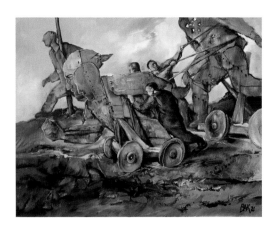

HELPERS

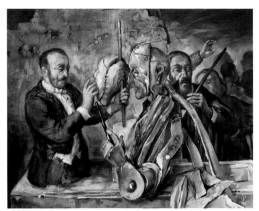

FOR A NEW SELF

~ PUTTING IT TOGETHER ~

We conclude with three works in which Bak brings together his integrated and dis-integrated figures to make the case for the possibility of, and necessity for, wholeness through collaboration and cooperation. In *Helpers* (BK2654), we see the possibility of integrated figures contributing their strength, and flattened figures their inspiration and drive, to a collaborative effort to move forward. In *For a New Self* (BK2652), a subject-figure magician helps an object-figure artist construct a new integrated self, drawing upon the memory and tradition of artists from the past. And in *Present Past* (BK2689), a reclining subject, a traveler-artist, finds inspiration in, but also liberation from, past selves carrying the weight of memory and lost home. His equipoise and openness speak to the possibility of release from the past and a future, if not unburdened, at least hopeful, and, provisionally, joyful.

~ LEAVING THE HOUSE ~

We descend from Sam's studio, overwhelmed by his productivity and the power of his vision, stepping back out of Sam Bak's mind. Sam bids us a gracious farewell and we drive out, his compact figure receding as we pass the sublime stone wall that now seems to reveal a Bakian ruined landscape, inserting itself into this world. A runner along the road now presents as satisfyingly, if precariously, whole, as she trots along a low stone farm wall, blithely pushing onward, unaware of the uncertainty that surrounds us. Indeed, the landscape is transformed as we

return to Boston to go and figure out what we have just seen, to step out of Samuel Bak's world and back into the stream of history, seeking the ships, nails and trumpets out of which to build a path to travel from a tragic past into an uncertain future, but with the hope that we can, with resolve, humor, love, and art, repair a broken world.

~

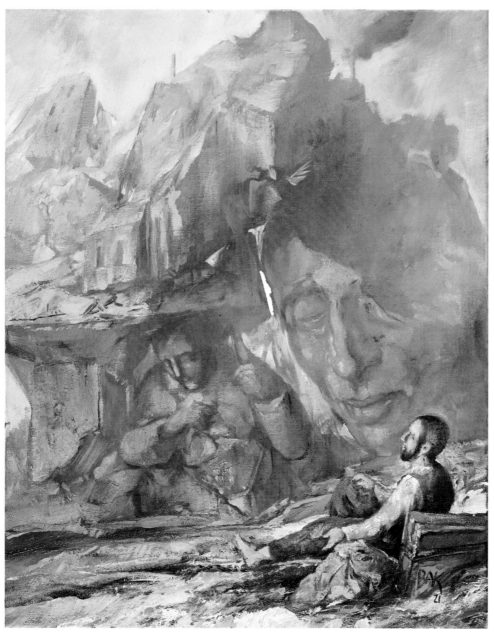

PRESENT PAST ~ 2021
Oil on canvas
20 x 16"
BK2689

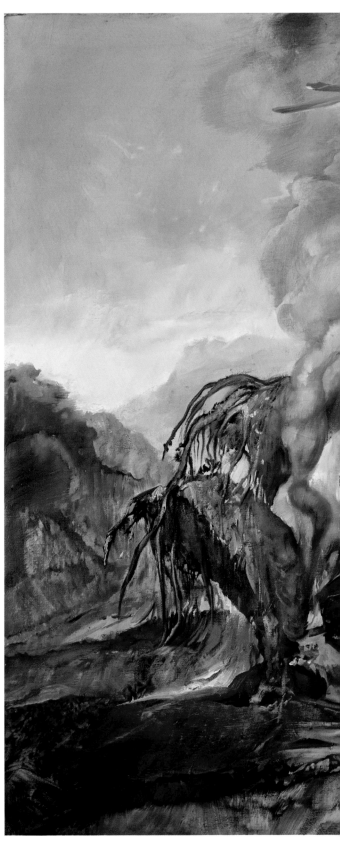

MUTUAL HELP ~ 2020
Oil on linen
30 x 40"
BK2595

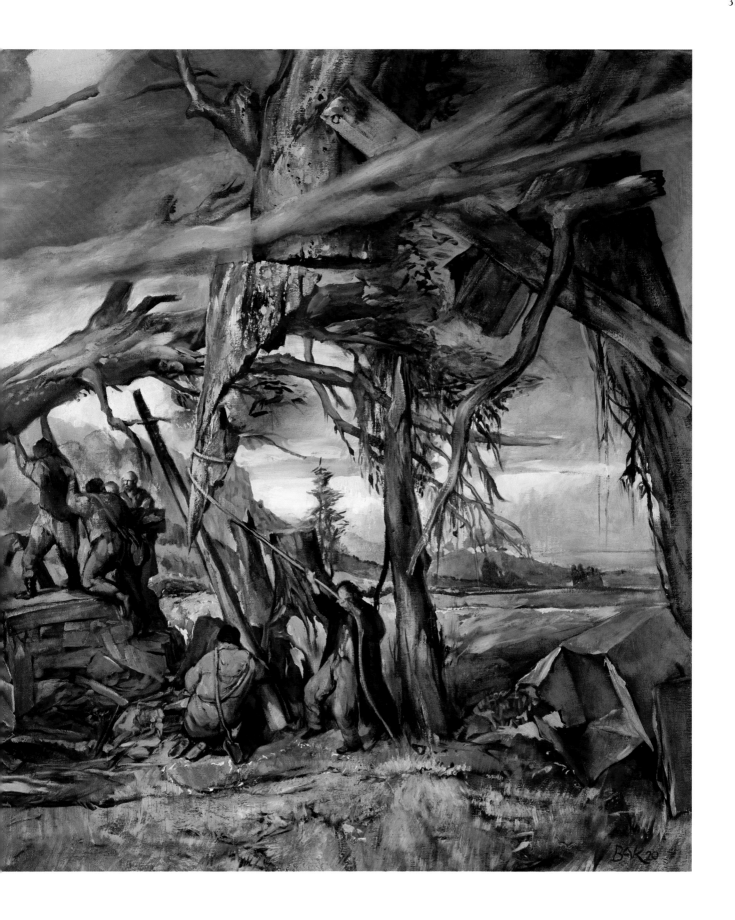

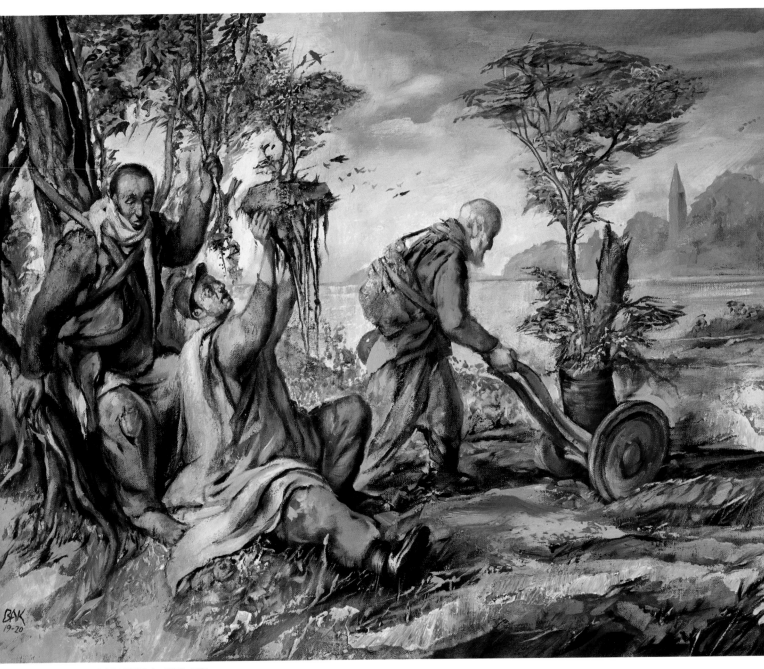

LANDSCAPERS A ~ 2019–2020
Oil on canvas
22 x 28"
BK2593

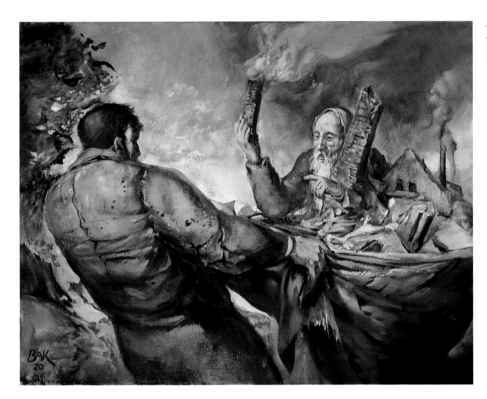

COMING ALONG ~ 2020
Oil on canvas
14 x 18"
BK2580

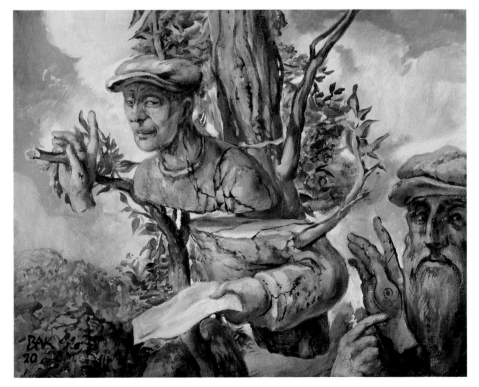

ONE OF ISAAKS STORIES ~ 2020
Oil on canvas
11 x 14"
BK2669

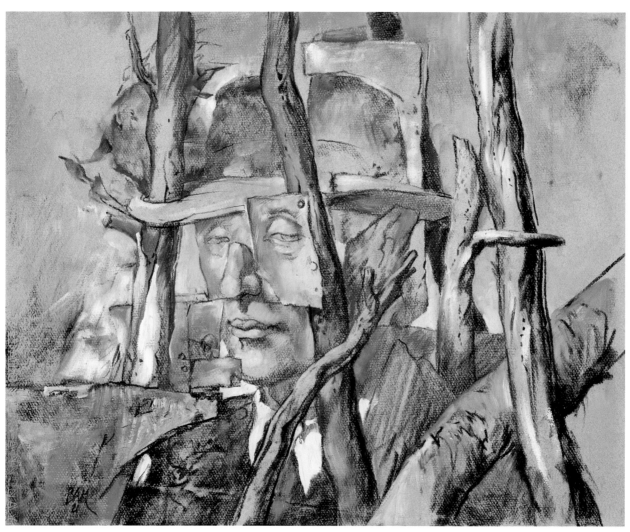

FROM LONG AGO ~ 2021
Charcoal and alkyd on brown/grey paper
15.75 x 19.75"
BK2618

Right: THE MAN MAKES THE HAT (OCTET 2/8), DETAIL ~ 2021
Oil on canvas
18 x 14"
BK2632

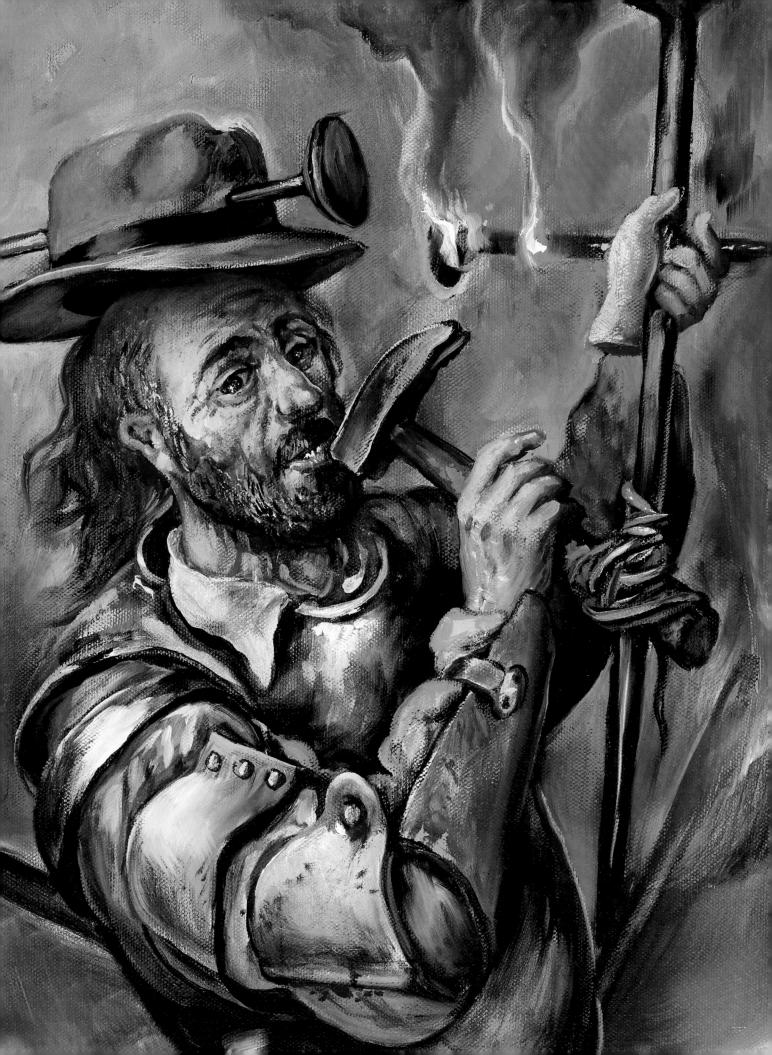

42

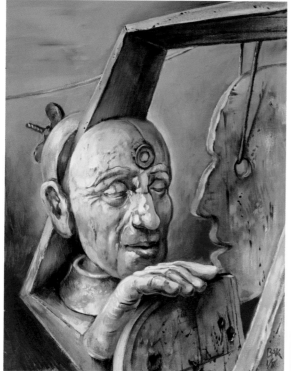
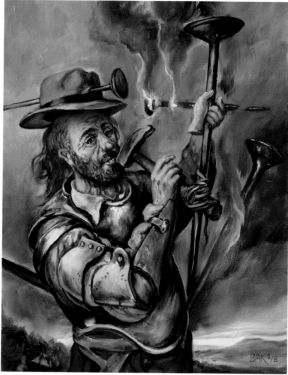
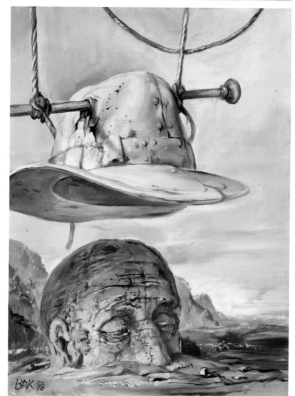
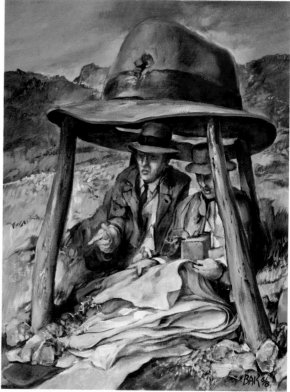

Top: THE MAN MAKES THE HAT (OCTET 1/8) ~ 2021
Oil on canvas
18 x 14"
BK2631

Bottom: THE MAN MAKES THE HAT (OCTET 5/8) ~ 2021
Oil on canvas
18 x 14"
BK2635

Top: THE MAN MAKES THE HAT (OCTET 2/8) ~ 2021
Oil on canvas
18 x 14"
BK2632

Bottom: THE MAN MAKES THE HAT (OCTET 6/8) ~ 2021
Oil on canvas
18 x 14"
BK2636

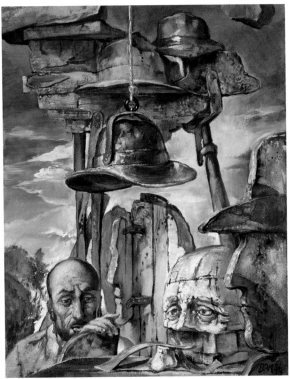

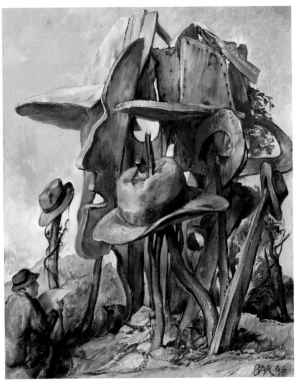

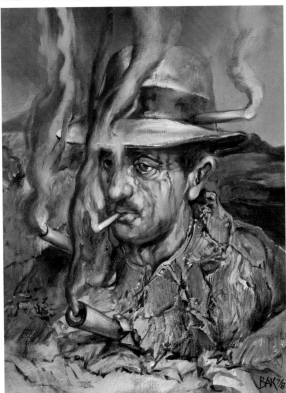

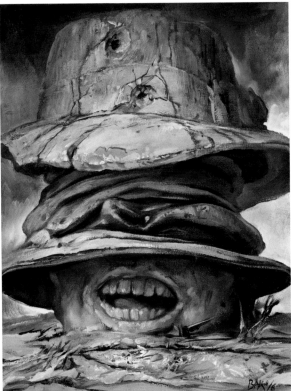

Top: THE MAN MAKES THE HAT (OCTET 3/8) ~ 2021
Oil on canvas
18 x 14"
BK2633

Bottom: THE MAN MAKES THE HAT (OCTET 7/8) ~ 2021
Oil on canvas
18 x 14"
BK2637

Top: THE MAN MAKES THE HAT (OCTET 4/8) ~ 2021
Oil on canvas
18 x 14"
BK2634

Bottom: THE MAN MAKES THE HAT (OCTET 8/8) ~ 2021
Oil on canvas
18 x 14"
BK2638

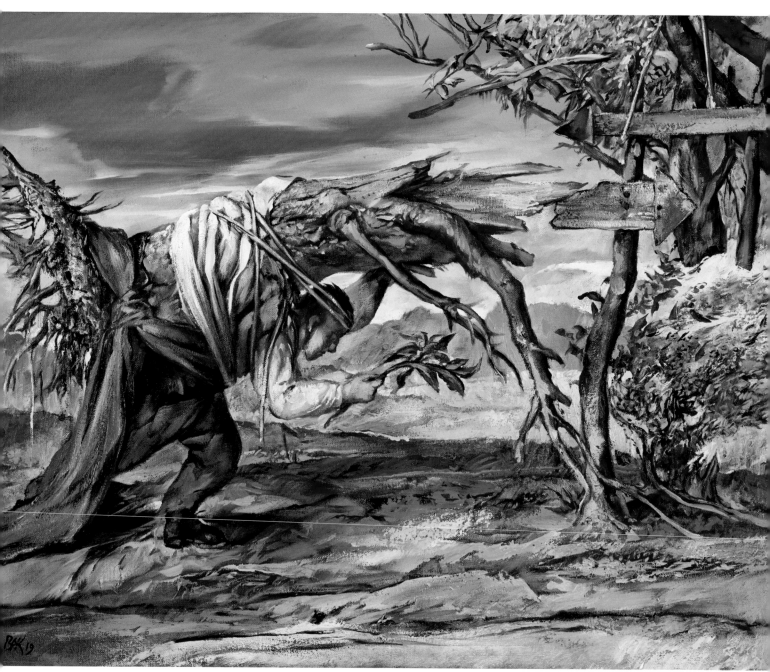

CONVEYANCE ~ 2019
Oil on canvas
22 x 28"
BK2582

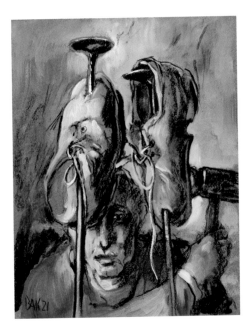

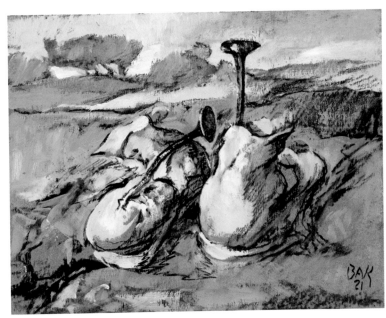

NOW WHAT? ~ 2021
Charcoal and alkyd on brown paper
11 x 8.5"
BK2610

FOR GOOD ~ 2021
Charcoal and alkyd on brown cardboard
8.5 x 11"
BK2605

NATURE AND MAN ~ 2020
Oil on canvas
18 x 14"
BK2663

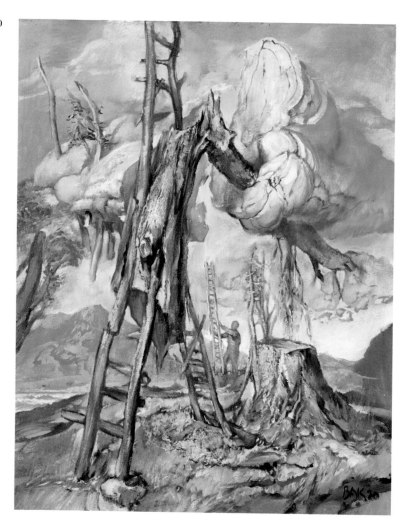

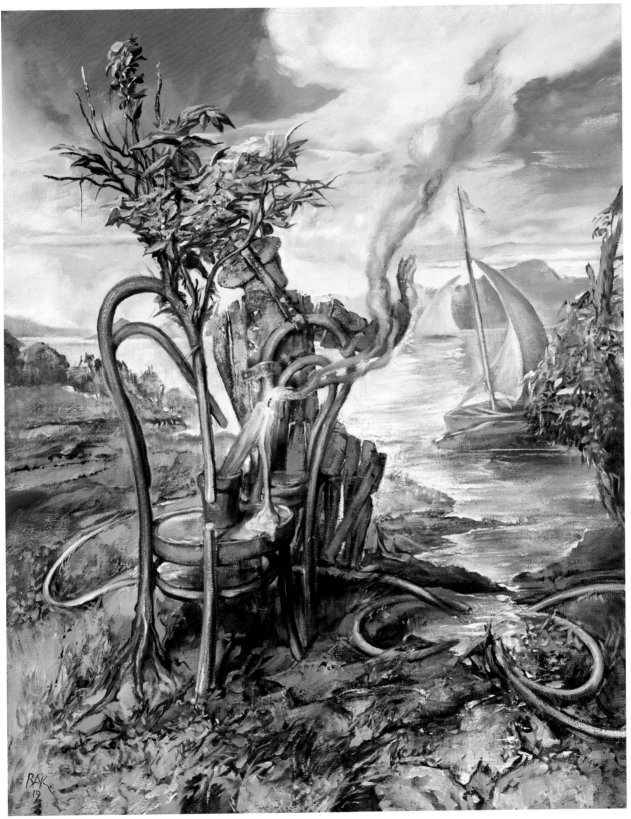

ISLANDER ~ 2019
Oil on canvas
28 x 22"
BK2591

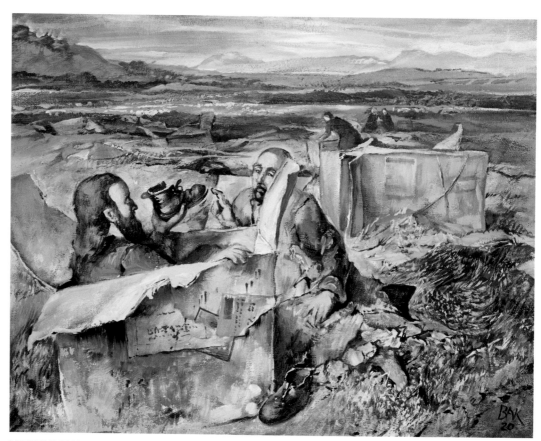

MOST IMPORTANTLY ~ 2020
Oil on canvas
14 x 18"
BK2594

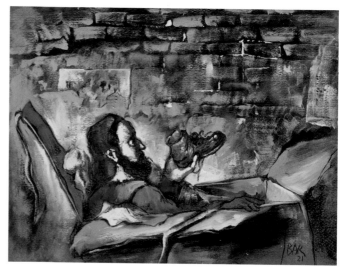

MOST IMPORTANTLY ~ 2021
Charcoal and alkyd on brown paper
10 x 13"
BK2606

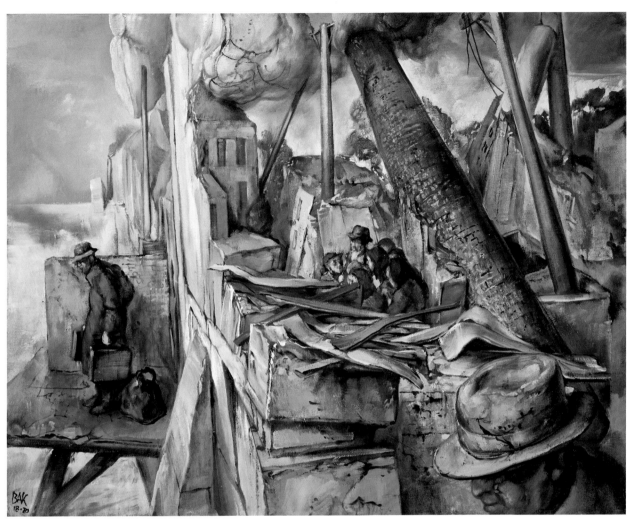

DEFINITIVE ~ 2018–2020
Oil on canvas
22 x 28"
BK2584

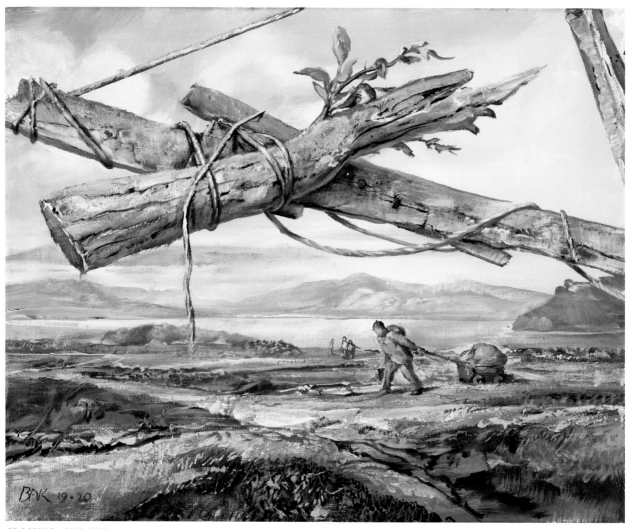

CROSSING ~ 2019–2020
Oil on canvas
16 x 20"
BK2583

Right: SUSPENDED FOR NOW ~ 2021
Oil on linen
48 x 36"
BK2714

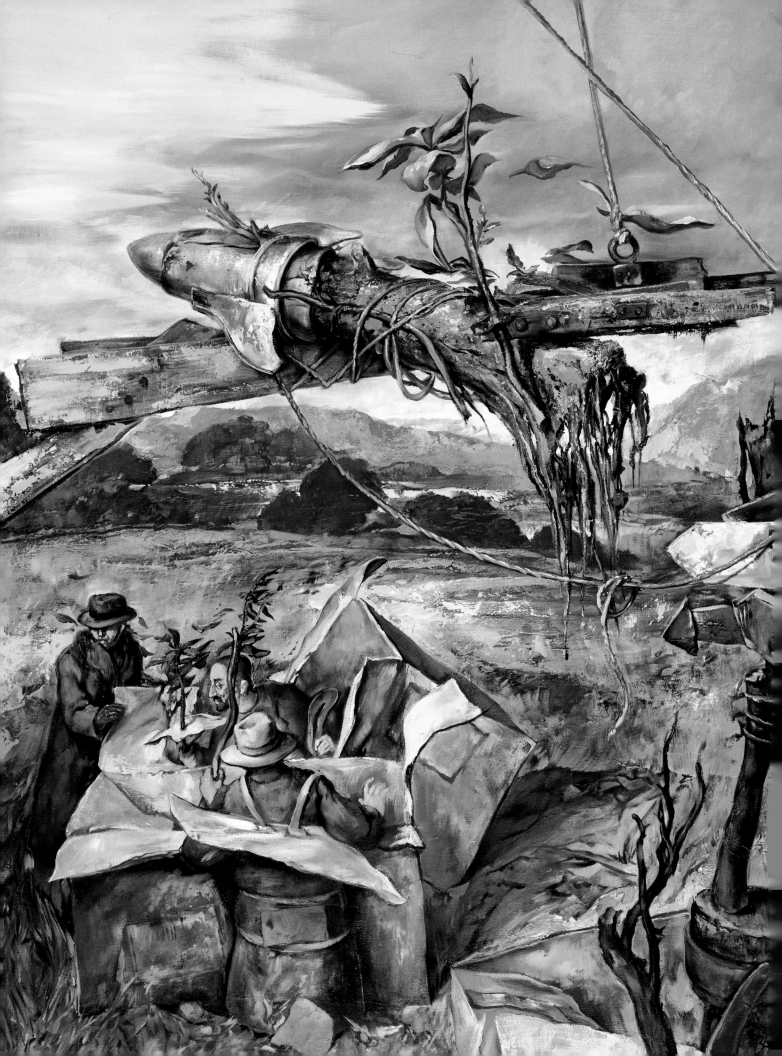

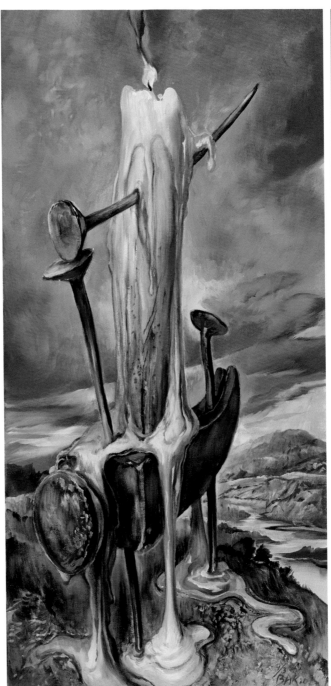

TRIPTYCH FOR THE NAMELESS ~ 2020
Oil on canvas
left and right panels: 30 x 15.25"; center panel: 30 x 24"
BK2696-BK2698

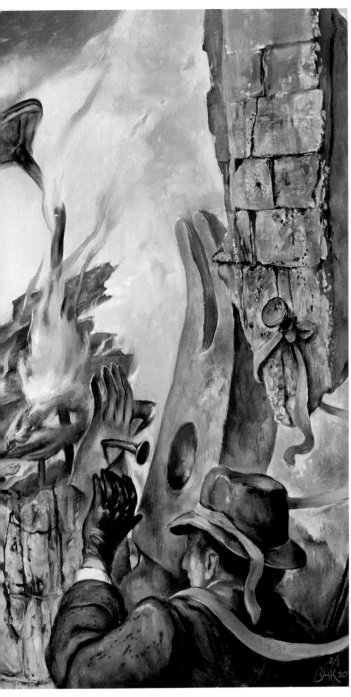

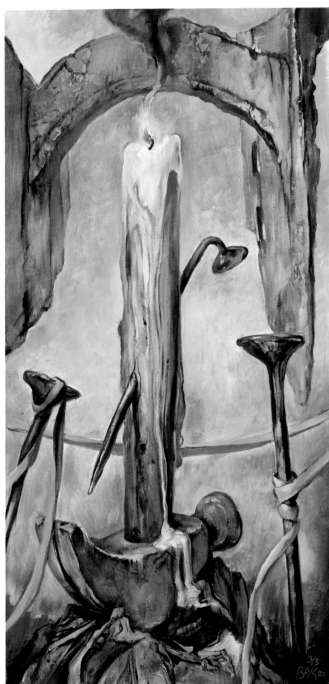

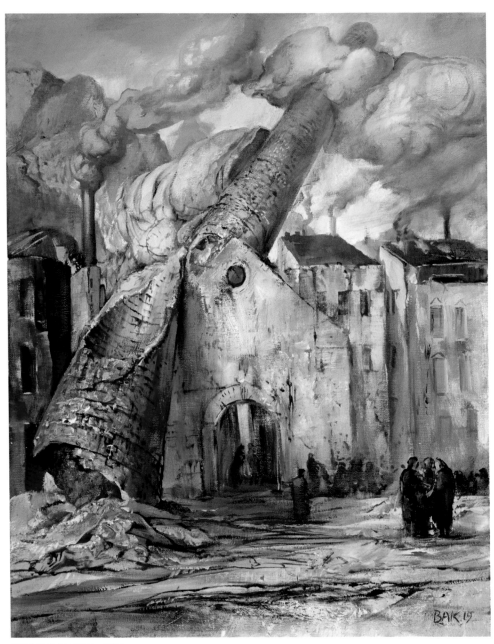

THE WAR IS OVER ~ 2019
Oil on canvas
20 x 16"
BK2628

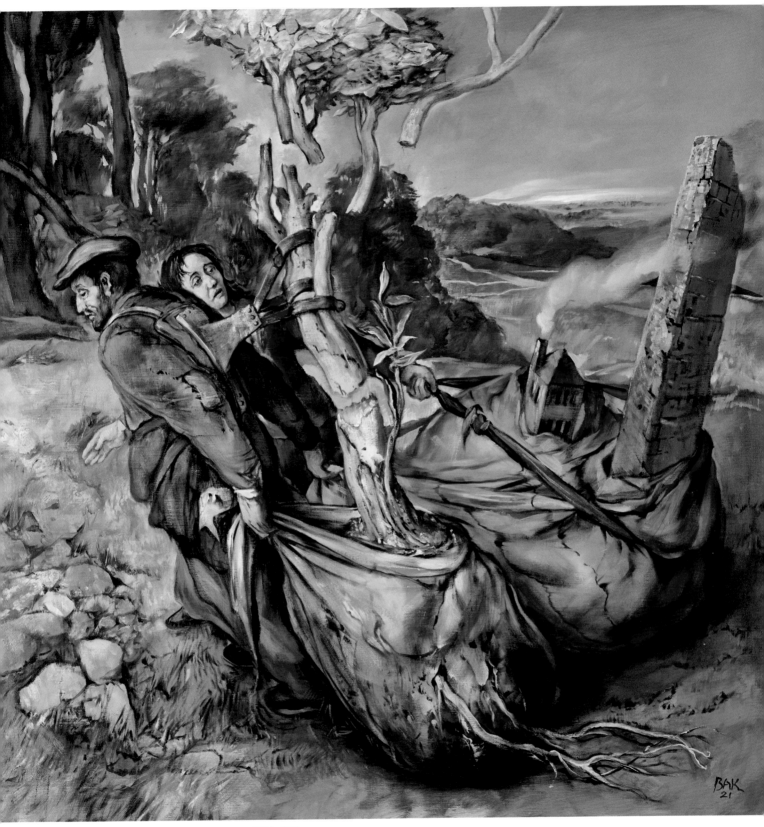

ADAM AND EVE AND THEIR RESETTLEMENT ~ 2021
Oil on linen
36 x 36"
BK2711

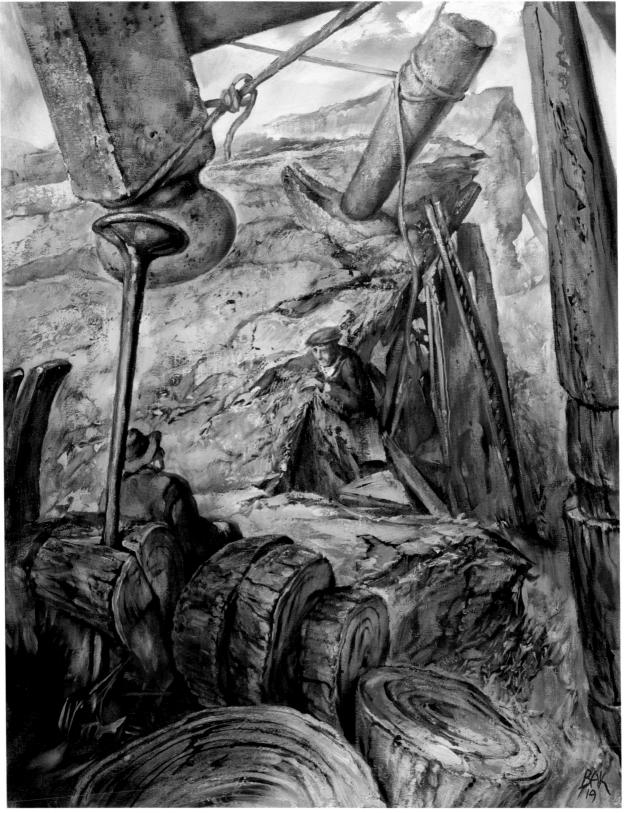

ON THE BRINK ~ 2019
Oil on canvas
28 x 22"
BK2702

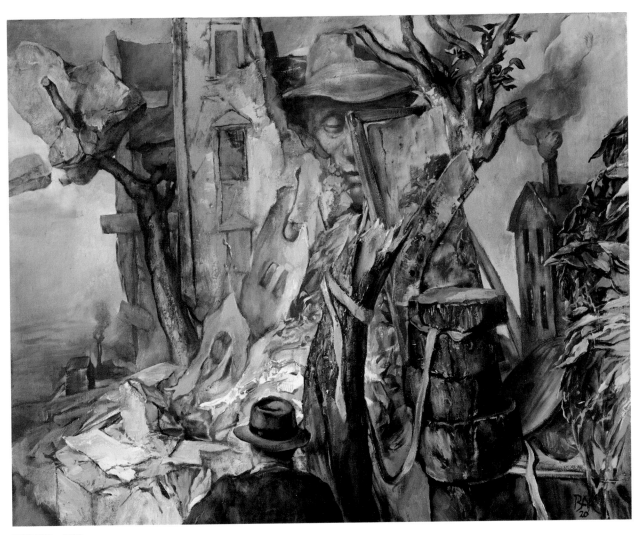

BYGONE ~ 2020
Oil on canvas
22 x 28"
BK2701

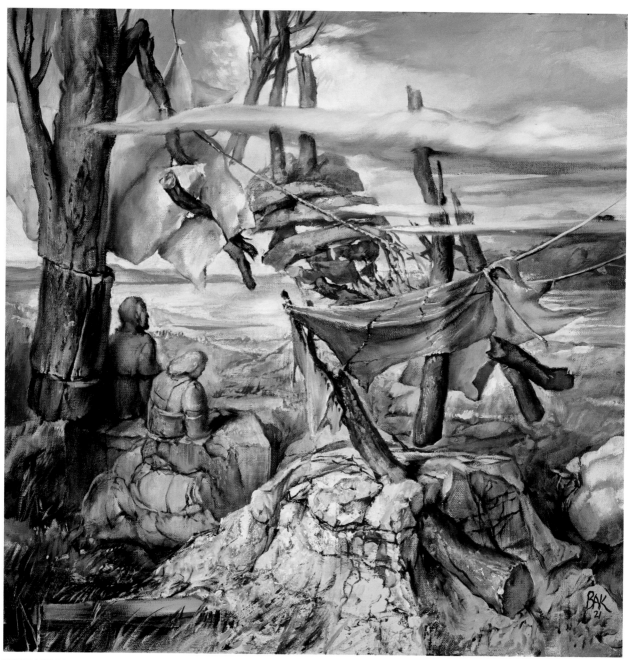

NEW LANDSCAPE FOR ADAM AND EVE ~ 2021
Oil on canvas
24 x 24"
BK2596

Right: JACOB'S LATEST ~ 2019-2020
Oil on linen
48 x 36"
BK2716

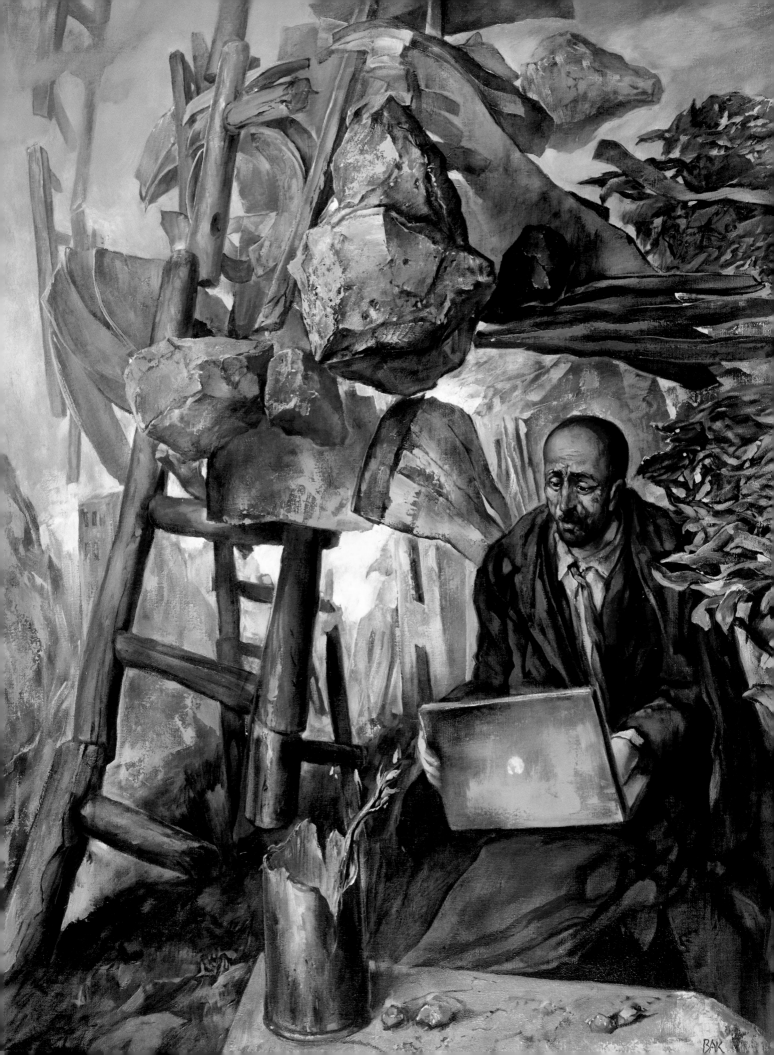

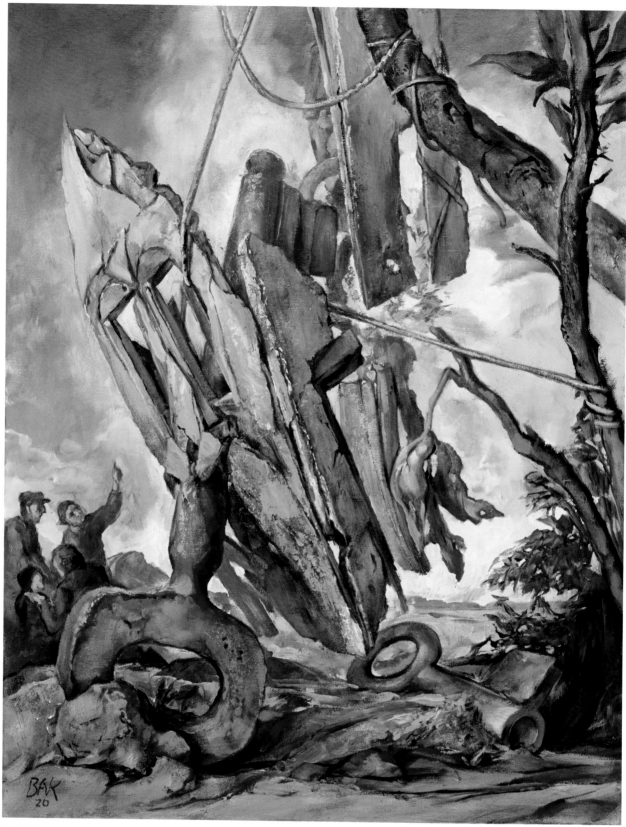

PAST EVER PRESENT ~ 2020
Oil on canvas
28 x 22"
BK2704

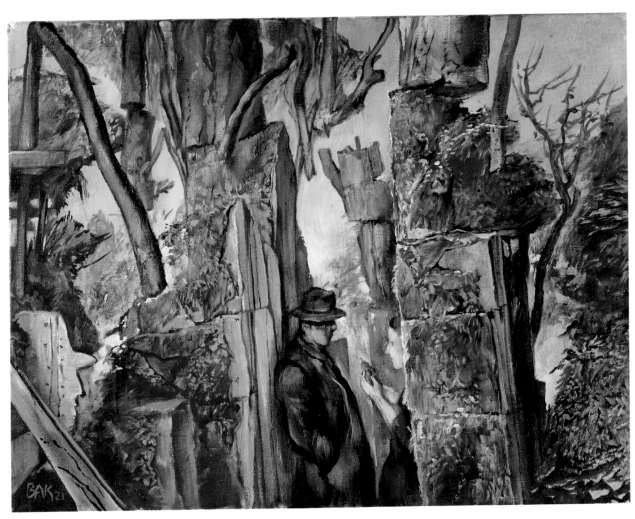

IN A NEW PARADISE ~ 2021
Oil on canvas
14 x 18"
BK2660

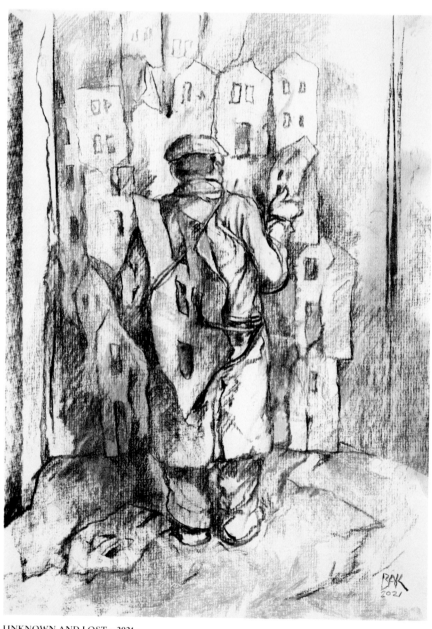

UNKNOWN AND LOST ~ 2021
Charcoal and pastel on paper
19 x 13.5"
BK2620

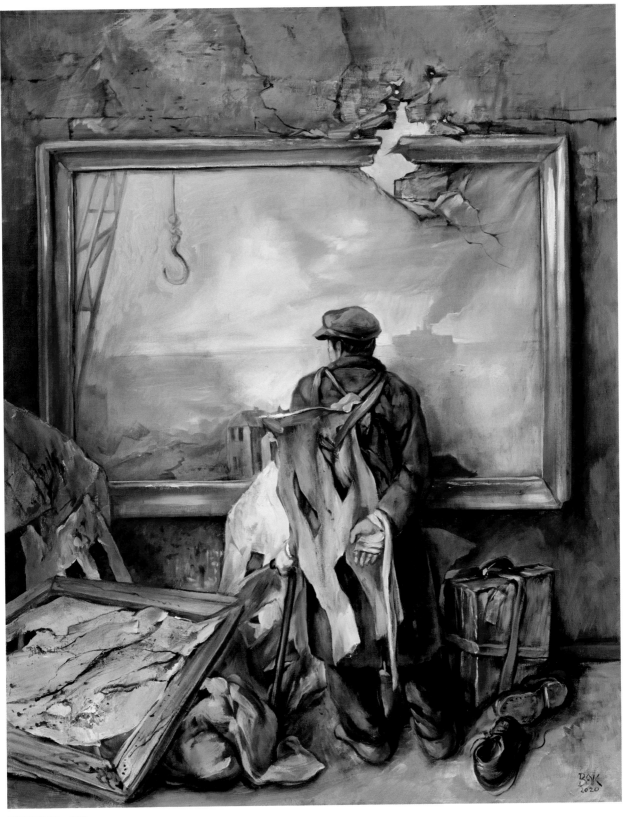

BEHOLDER ~ 2020
Oil on linen
32 x 25.5"
BK2577

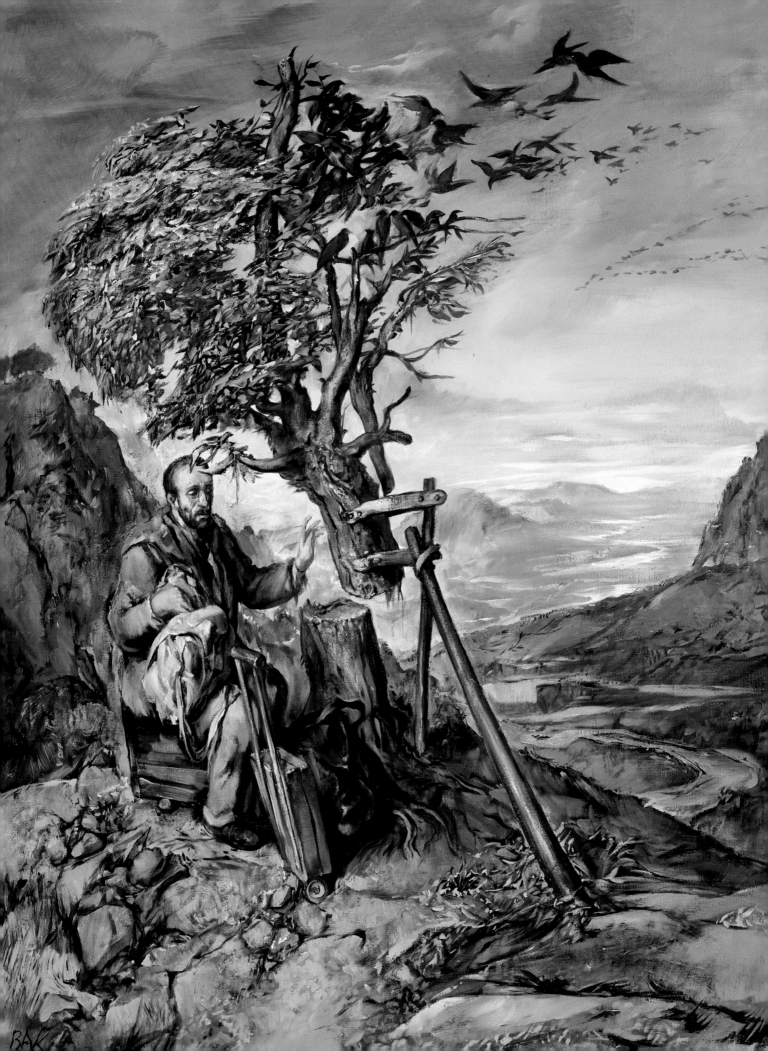

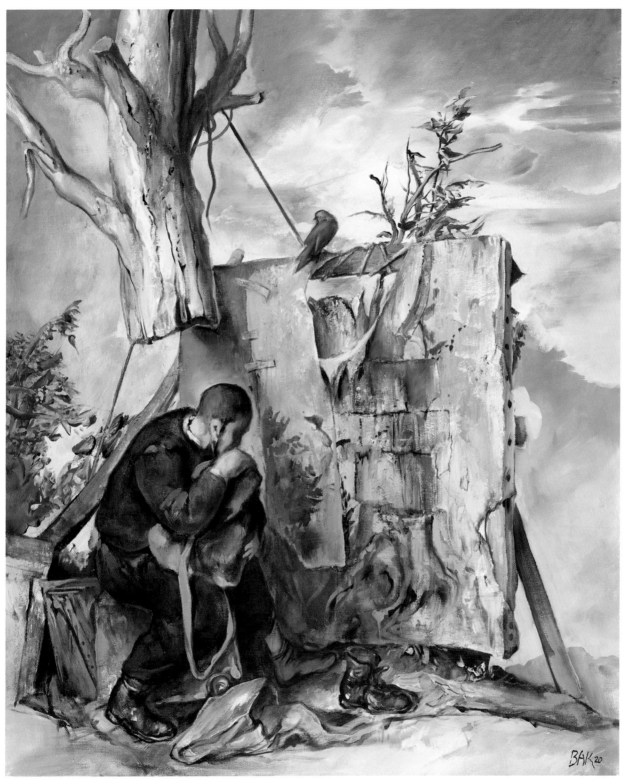

PAINTED ~ 2020
Oil on canvas
28 x 24"
BK2706

Left: STOP OVER ~ 2018
Oil on linen
40 x 30"
BK2622

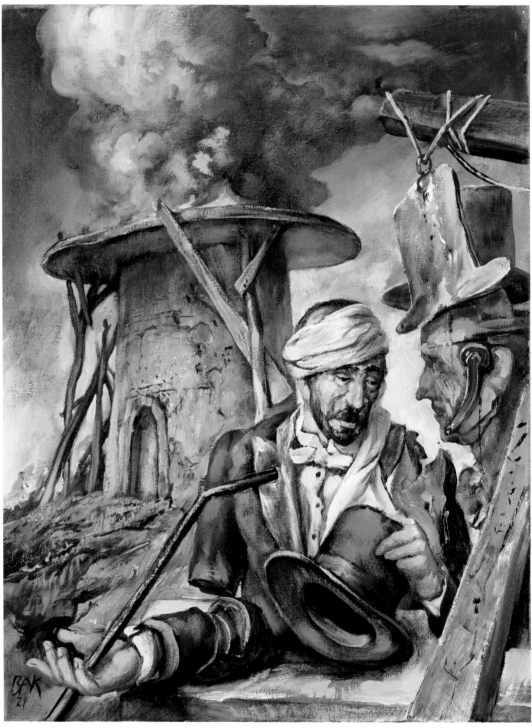

THE END OF A STORY ~ 2021
Oil on canvas
18 x 14"
BK2661

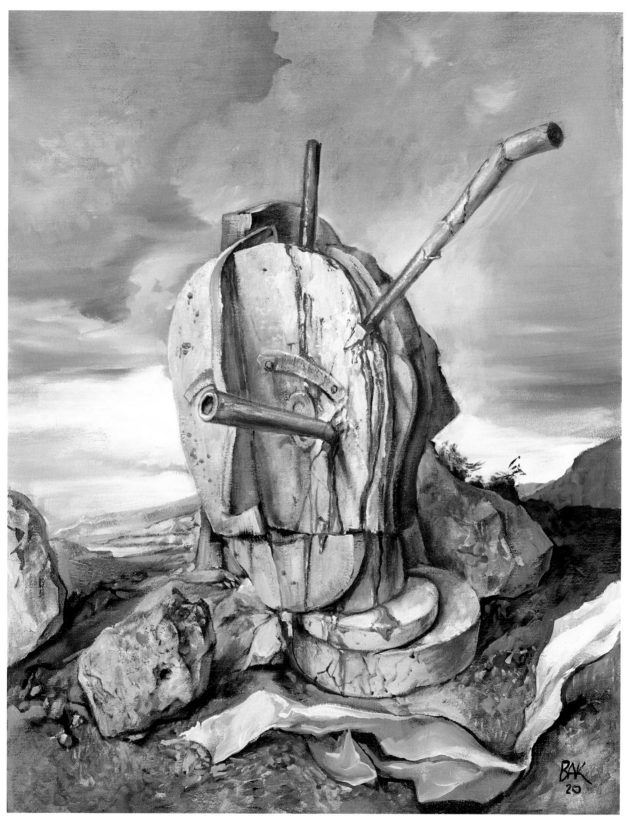

INFLUENCEABLE ~ 2020
Oil on canvas
20 x 16"
BK2682

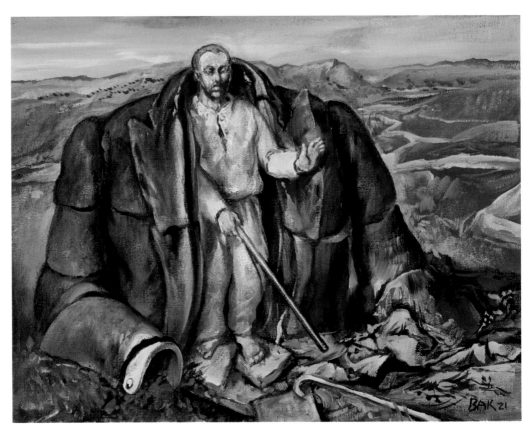

STUDY FOR BLIND MAGICIAN ~ 2021
Oil on canvas
11 x 14"
BK2672

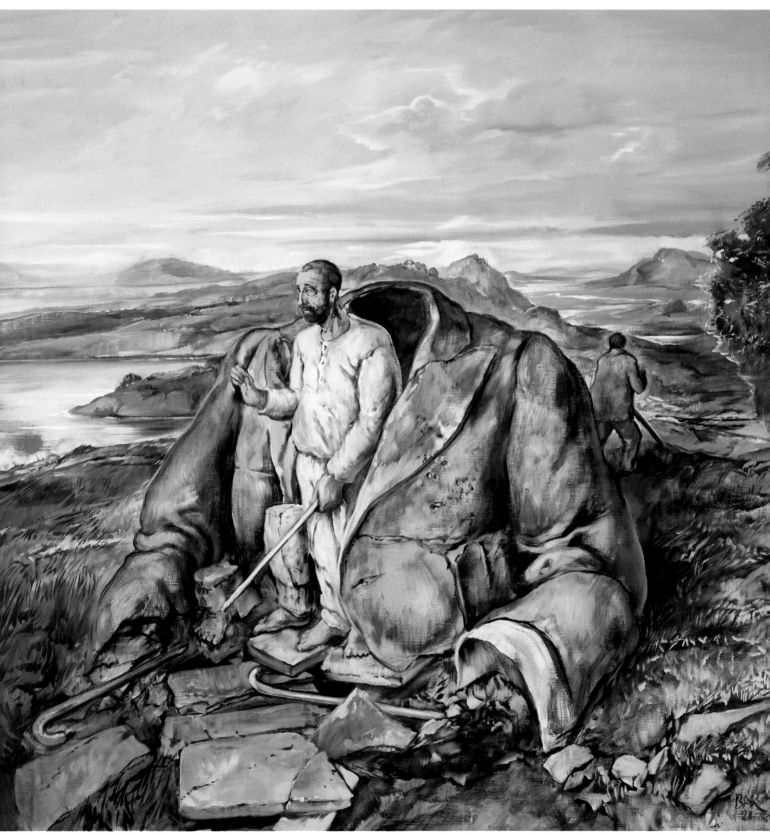

THE BLIND MAGICIAN ~ 2021
Oil on linen
36 x 36"
BK2709

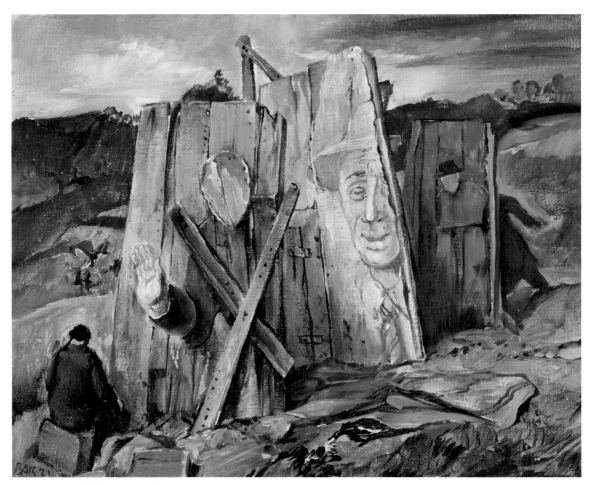

DETAILS OF OBSERVATION ~ 2021
Oil on canvas
11 x 14"
BK2667

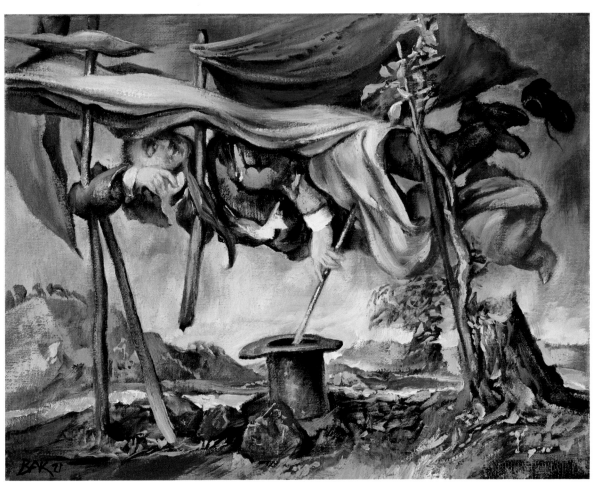

A MAGICIANS REST ~ 2021
Oil on canvas
11 x 14"
BK2668

THE MAGICIAN'S CURTAIN ~ 2021
Oil on canvas
11 x 14"
BK2670

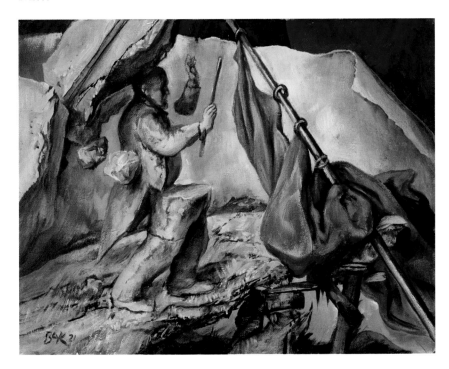

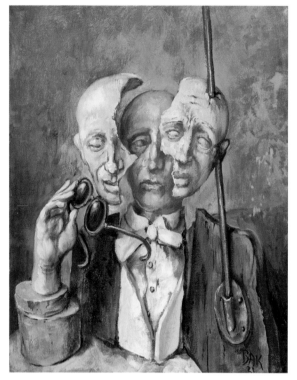

AS SEEN ~ 2021
Oil on canvas
14 x 11"
BK2677

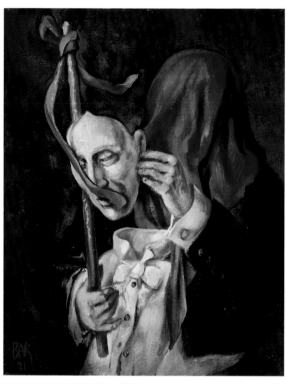

VISIBLE INVISABILITY ~ 2021
Oil on canvas
14 x 11"
BK2675

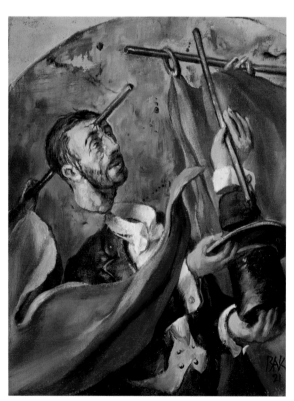

THE POSSIBILITY OF THE IMPOSSIBLE ~ 2021
Oil on canvas
14 x 11"
BK2676

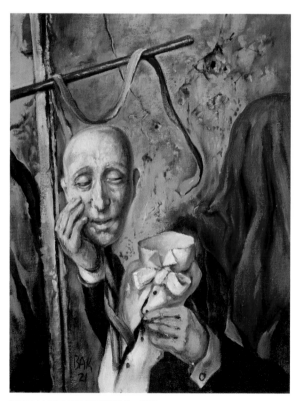

REVEALING THE VISABLE ~ 2021
Oil on canvas
14 x 11"
BK2674

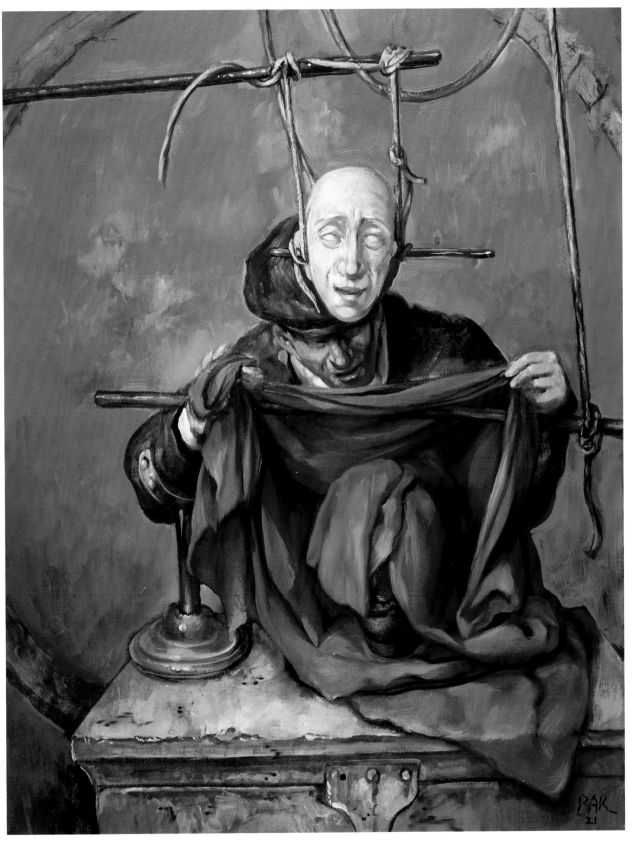

THE ONE AND ONLY ~ 2021
Oil on canvas
28 x 22"
BK2705

ON THE INADMISSIBLE ~ 2018
Oil on canvas
16 x 20"
BK2597

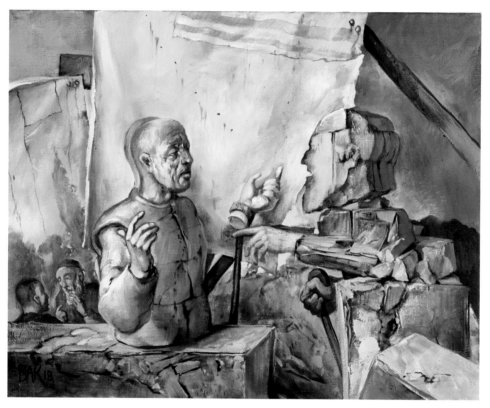

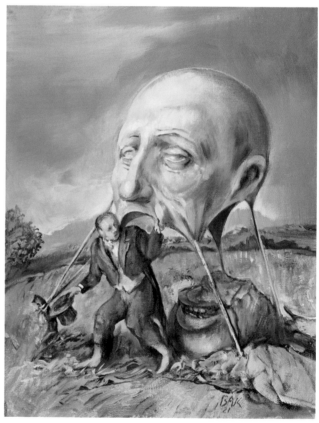

EGO AND SUPEREGO ~ 2021
Oil on canvas
14 x 11"
BK2673

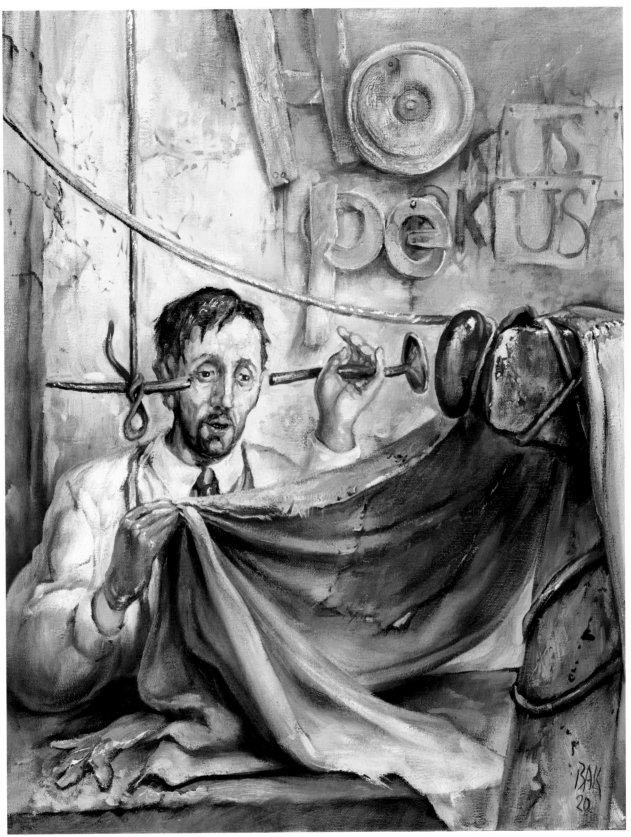

ENDURING, A - 2020
Oil on canvas
20 x 16"
BK2683

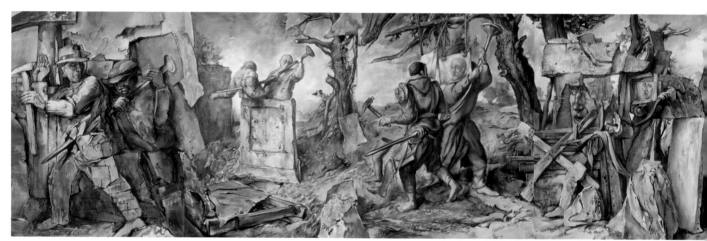

Inset: NAILINGS A–G (SEPTET 1-7) ~ 2021
Oil on canvas
20 x 16" each
BK2639–BK2645

Right: NAILINGS, A (SEPTET 1/7), DETAIL ~ 2021
Oil on canvas
20 x 16"
BK2639

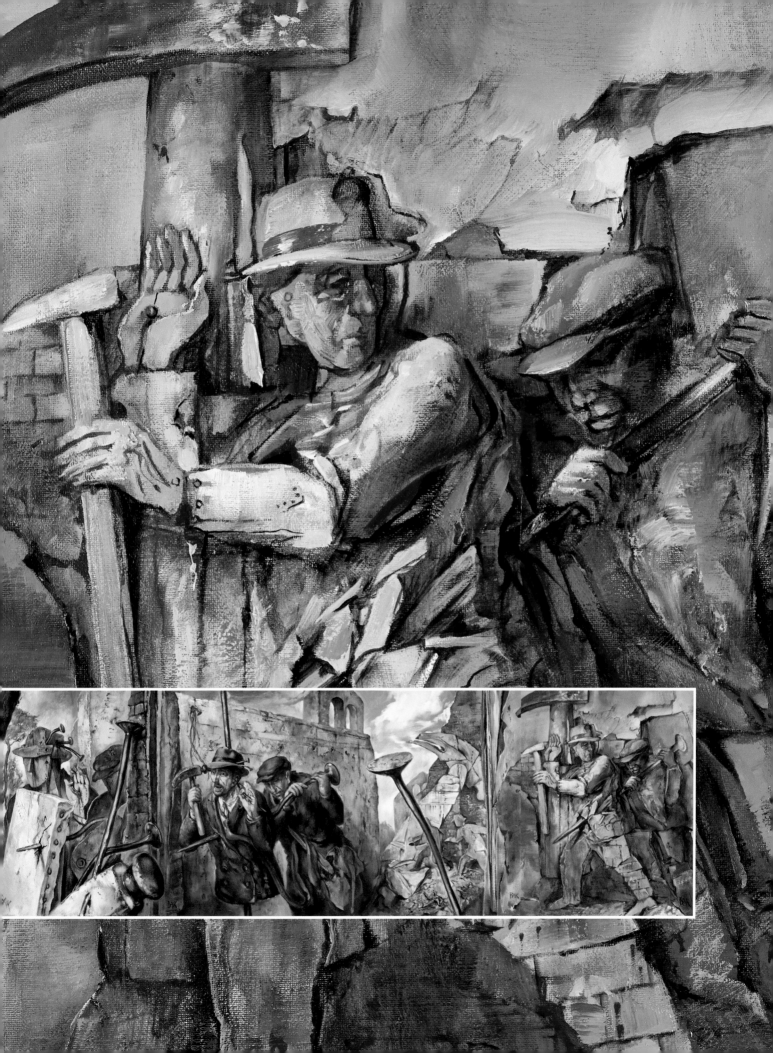

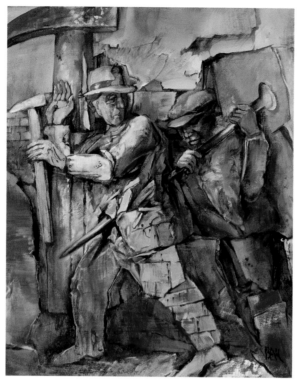

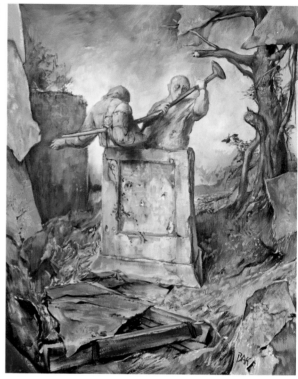

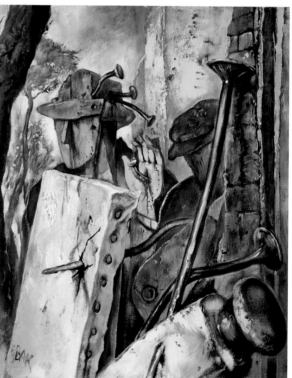

Top: NAILINGS, A (SEPTET 1/7) ~ 2021
Oil on canvas
20 x 16"
BK2639

Top: NAILINGS, B (SEPTET 2/7) ~ 2021
Oil on canvas
20 x 16"
BK2640

Bottom: NAILINGS, E (SEPTET 5/7) ~ 2021
Oil on canvas
20 x 16"
BK2643

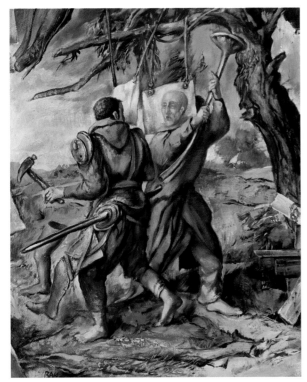

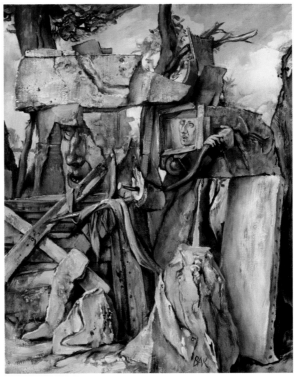

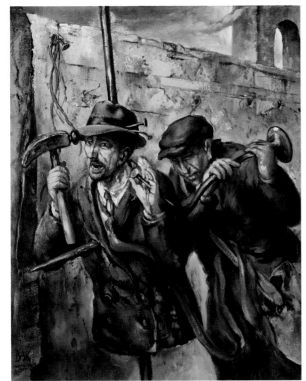

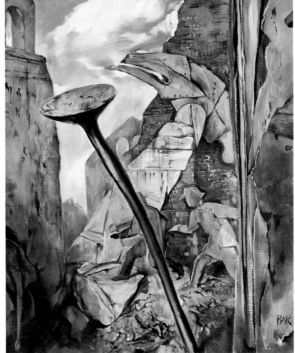

Top: NAILINGS, C (SEPTET 3/7) ~ 2021
Oil on canvas
20 x 16"
BK2641

Bottom: NAILINGS, F (SEPTET 6/7) ~ 2021
Oil on canvas
20 x 16"
BK2644

Top: NAILINGS, D (SEPTET 4/7) ~ 2021
Oil on canvas
20 x 16"
BK2642

Bottom: NAILINGS, G (SEPTET 7/7) ~ 2021
Oil on canvas
20 x 16"
BK2645

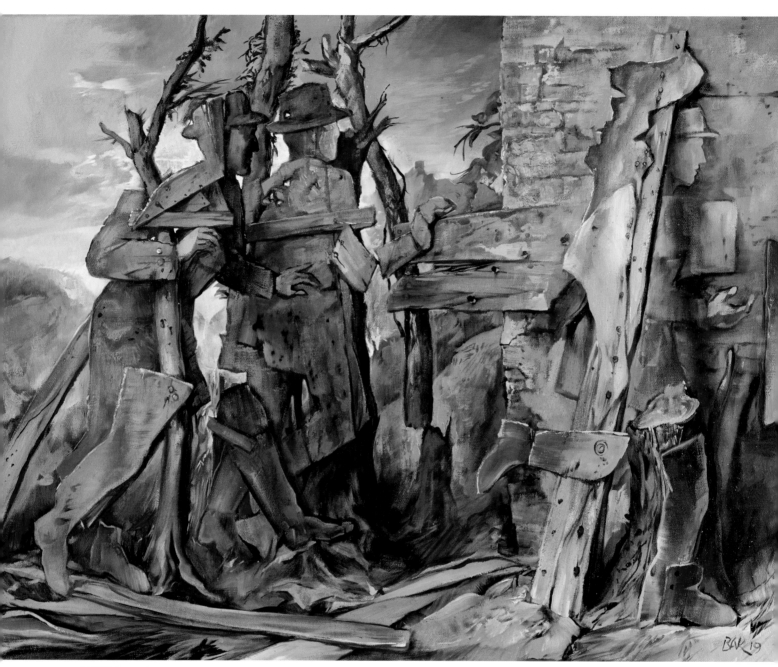

IN THE SAME DIRECTION ~ 2019
Oil on canvas
22 x 28"
BK2590

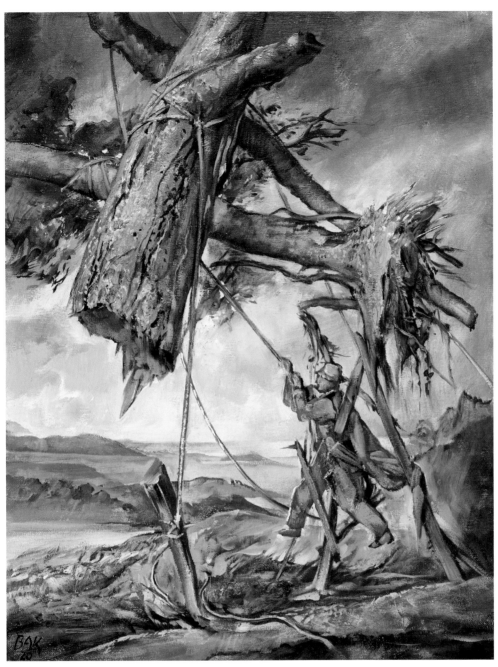

HOLDING ON ~ 2020
Oil on canvas
20 x 16"
BK2687

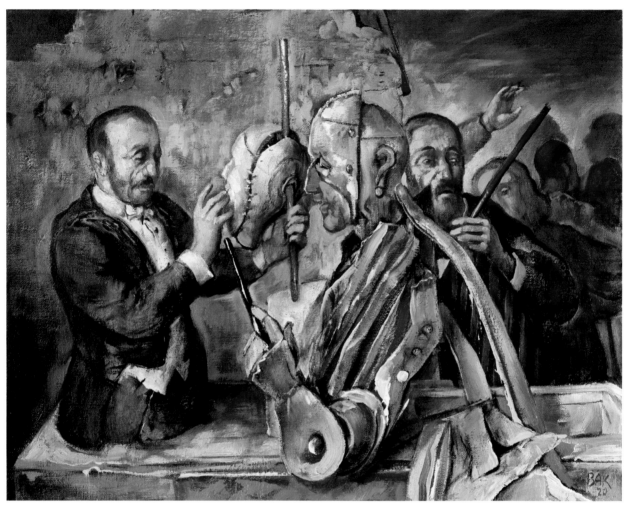

FOR A NEW SELF ~ 2020
Oil on canvas
14 x 18"
BK2652

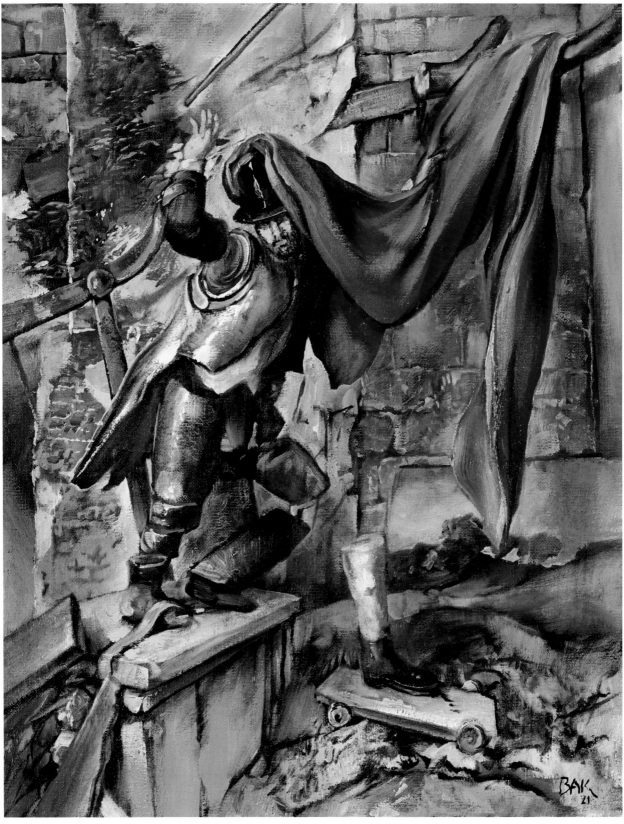

KNIGHTED ~ 2021
Oil on canvas
18 x 14"
BK2730

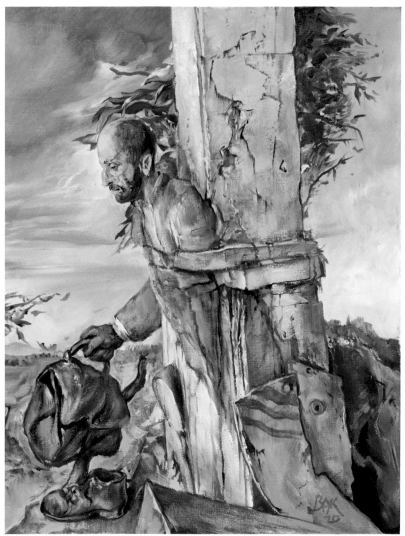

TRIPTYCH OF INESCAPABLE LOT ~ 2020
Oil on canvas
20 x 16" each
BK2647–BK2649

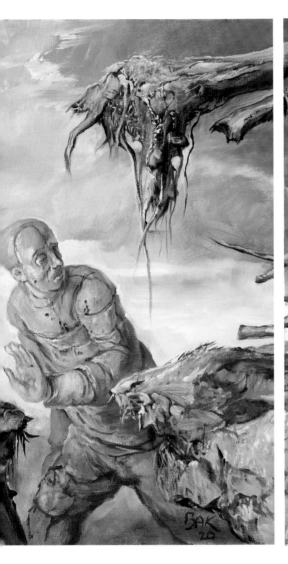

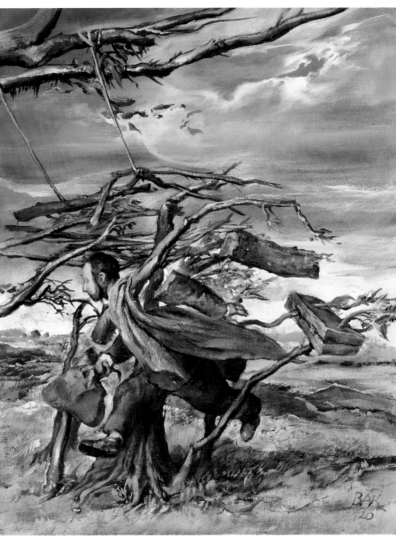

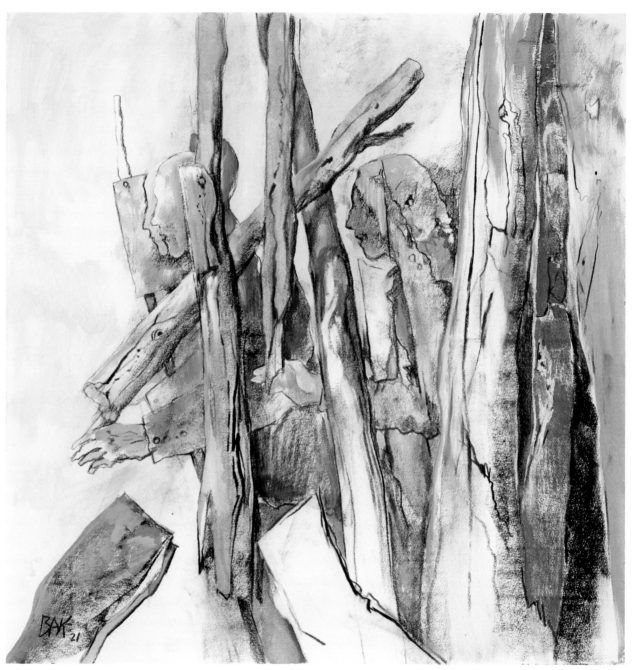

IN BETWEEN ~ 2021
Gouache, oil, and pencil on paper
20 x 20"
BK2724

Right: TEMPORARY PERMANENCE ~ 2020
Oil on linen
40 x 30"
BK2713

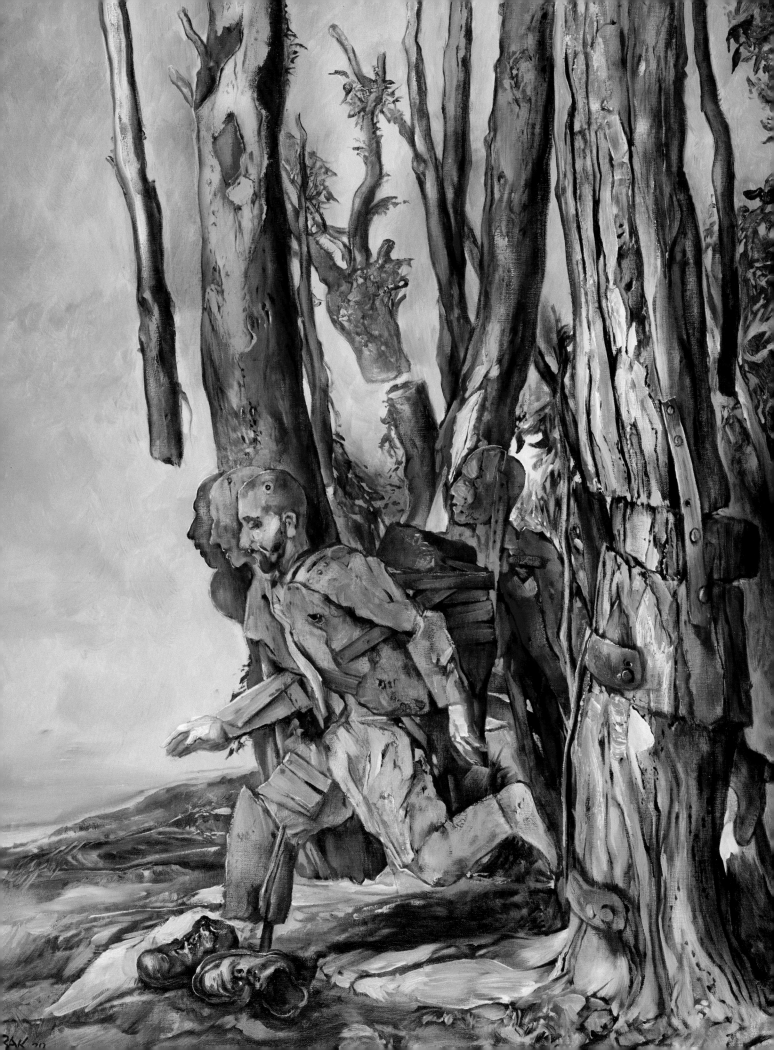

WITH TIME ~ 2019–2021
Oil on linen
36 x 48"
BK2715

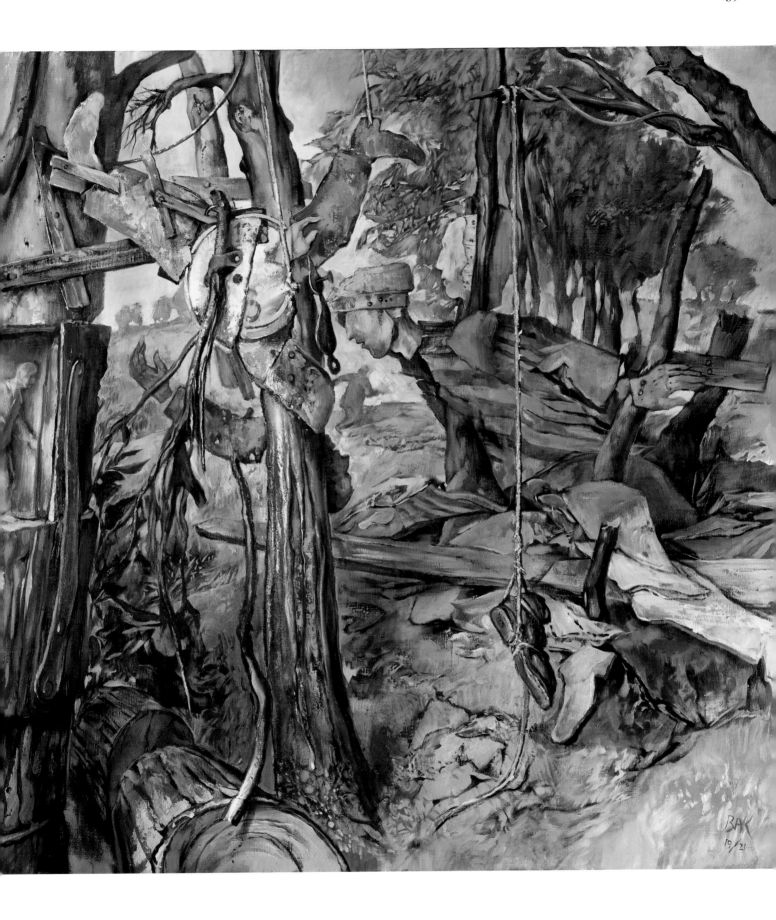

HELPERS ~ 2021
Oil on canvas
14 x 18"
BK2654

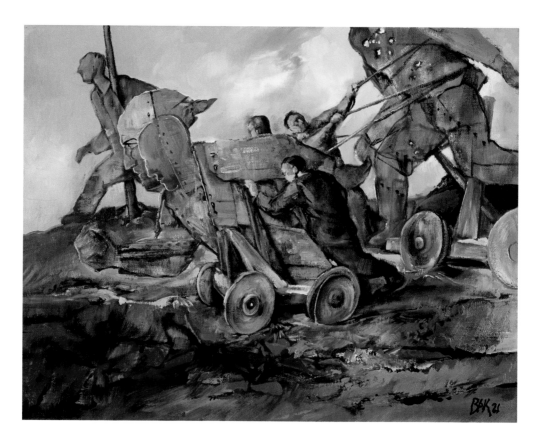

THE SKY IS CLEAR ~ 2021
Oil on canvas
16 x 20"
BK2681

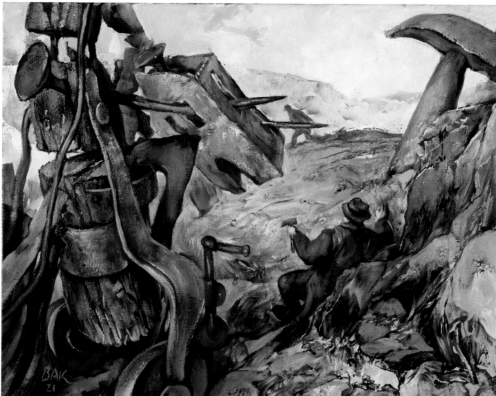

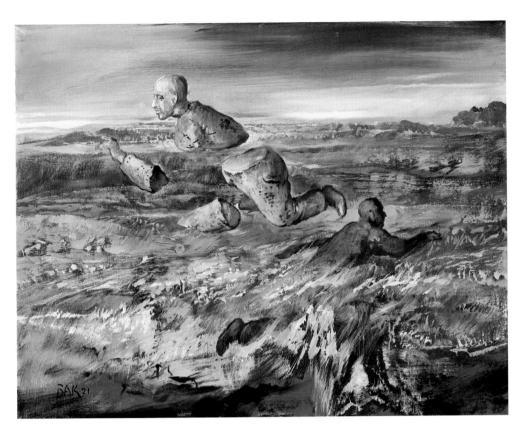

IN FLIGHT ~ 2021
Oil on canvas
14 x 18"
BK2656

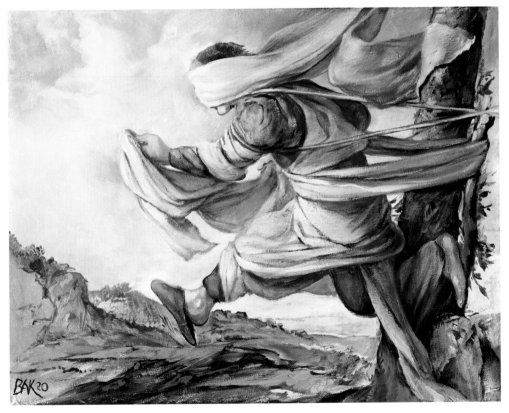

FOR INNER FREEDOM ~ 2020
Oil on canvas
14 x 18"
BK2658

92

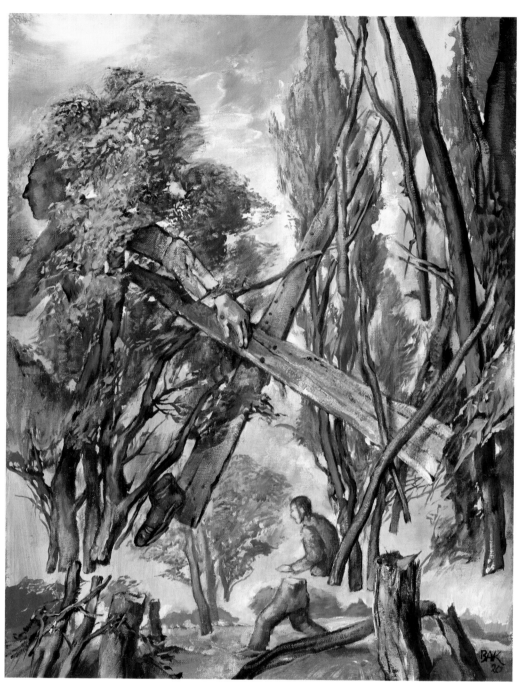

TO THE UNKNOWN ~ 2020
Oil on canvas
20 x 16"
BK2629

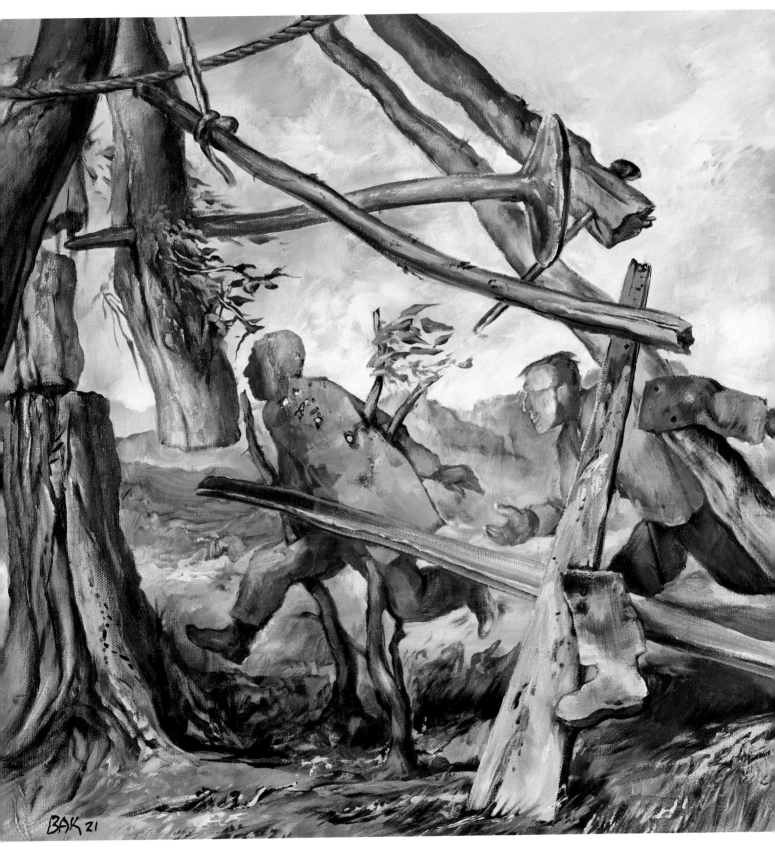

IN SPITE OF SOME OBSTACLES ~ 2021
Oil on canvas
20 x 20"
BK2646

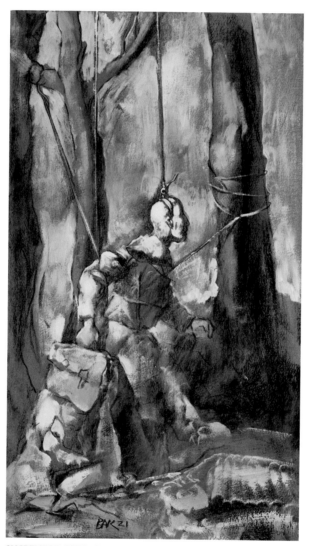

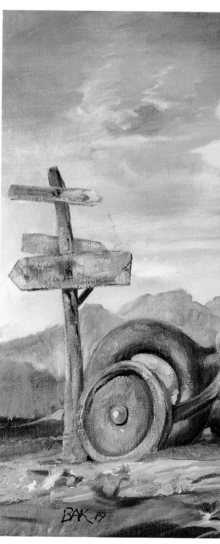

SUSPENDED RUN ~ 2021
Charcoal and alkyd on brown paper
16.75 x 9.5"
BK2612

KEY-POWER ~ 2019
Oil on canvas
15.25 x 30"
BK2700

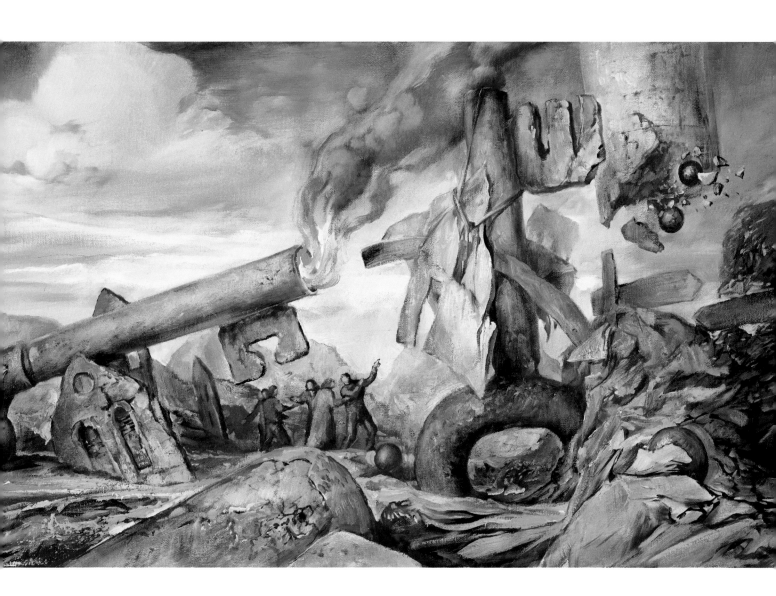

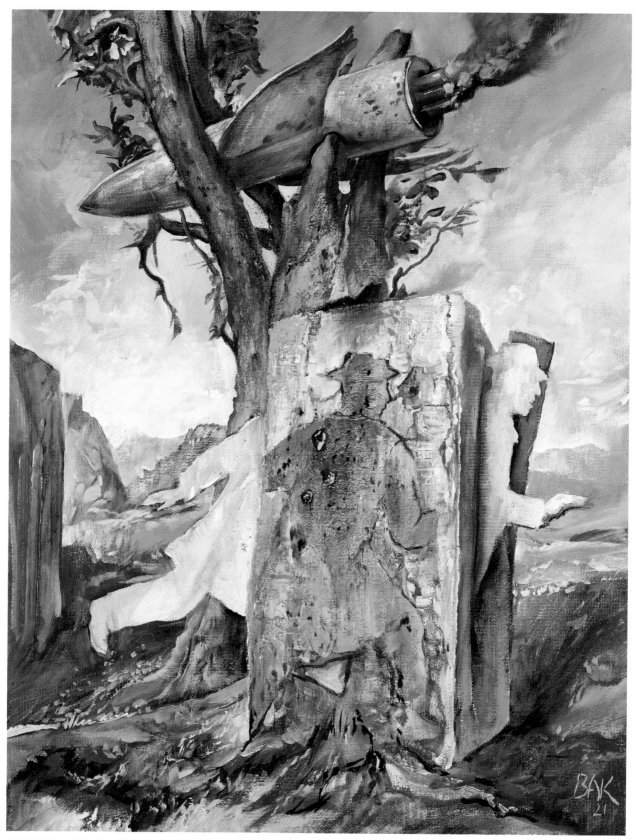

PERPETUAL MOTION ~ 2021
Oil on canvas
18 x 14"
BK2662

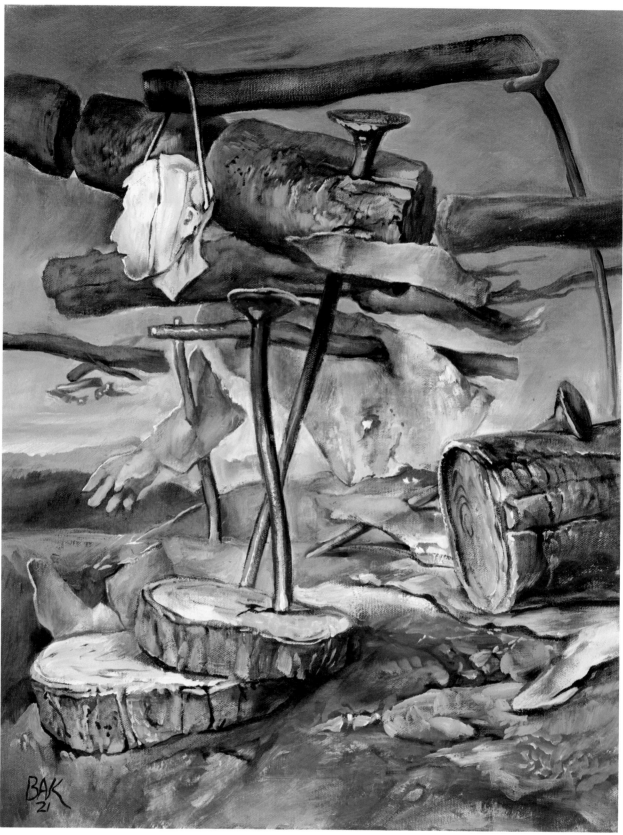

YET ANOTHER ESCAPE ~ 2021
Oil on canvas
20 x 16"
BK2686

STUDY FOR A CANCELLED
DEPARTURE ~ 2021
Oil on canvas
14 x 18"
BK2655

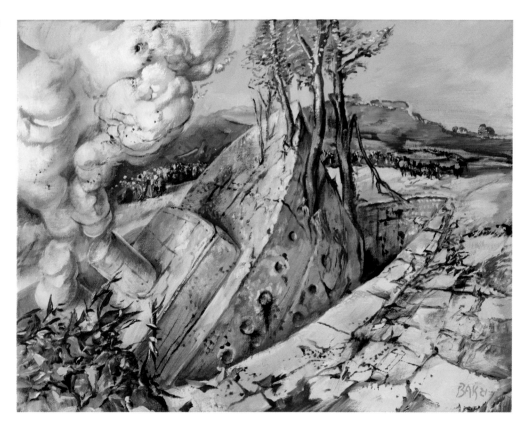

ONBOARD MAGIC ~ 2021
Oil on canvas
14 x 18"
BK2653

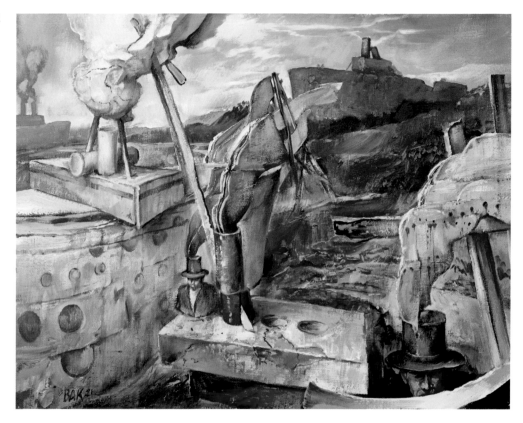

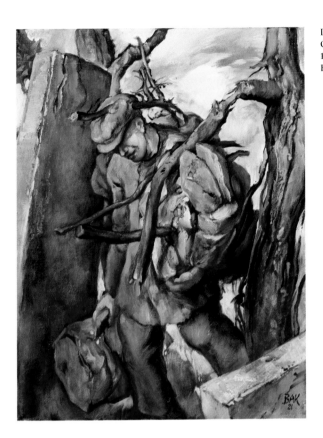

DETACHMENT ISSUE ~ 2021
Oil on canvas
18 x 14"
BK2650

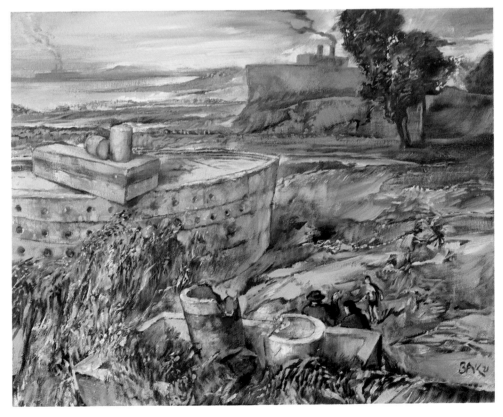

IN THE PARK OF ST. LOUIS ~ 2021
Oil on canvas
16 x 20"
BK2679

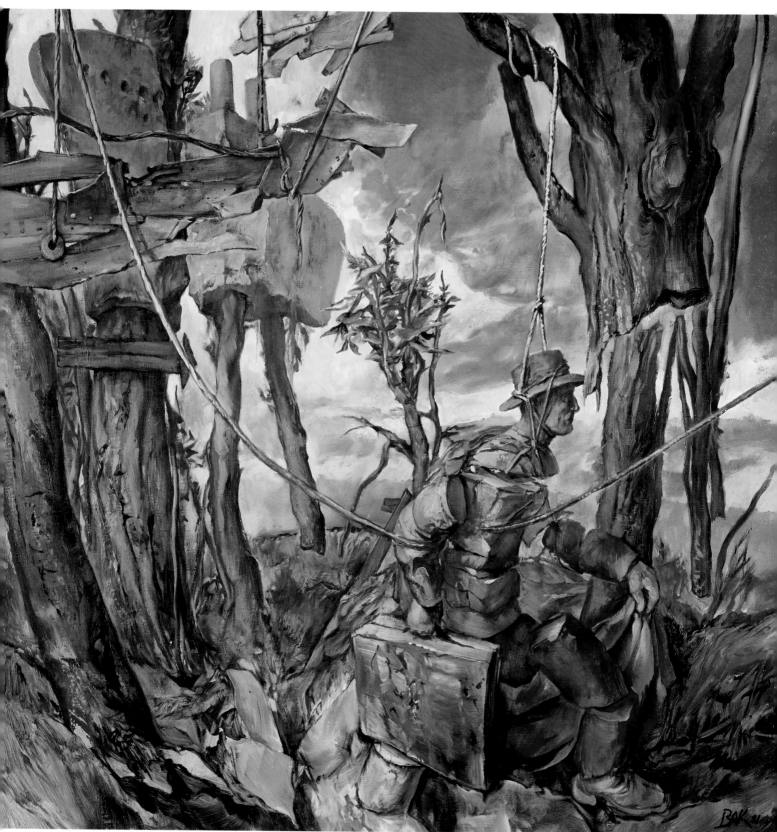

OFF THE ST. LOUIS ~ 2021
Oil on linen
36 x 36"
BK2717

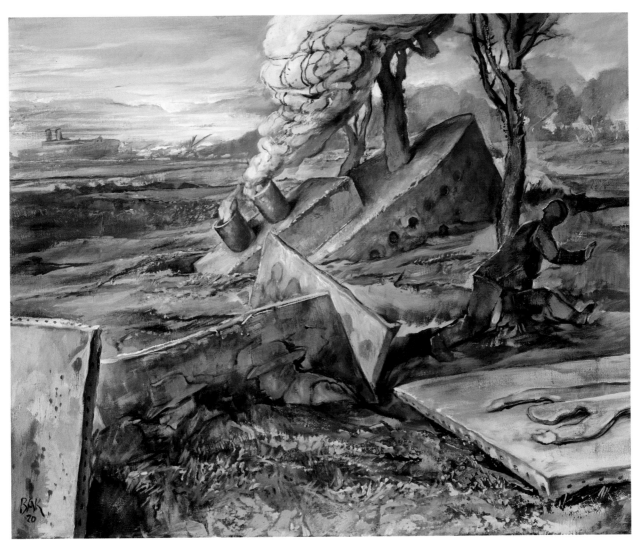

IN SEARCH OF A PORT ~ 2020
Oil on linen
20 x 25"
BK2693

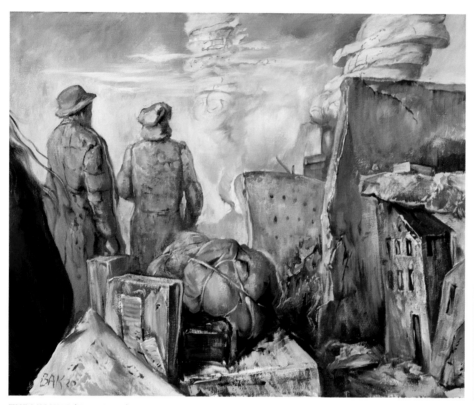

THE MISSING (TRIPTYCH) - 2020
Oil on canvas
16 x 20" each
BK2625 A-C

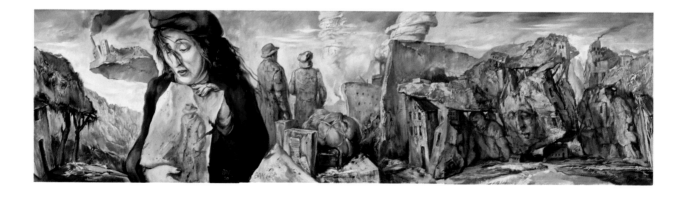

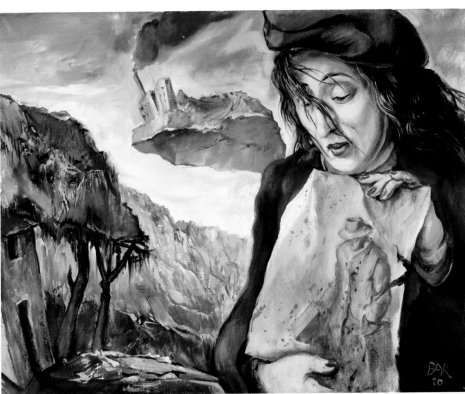
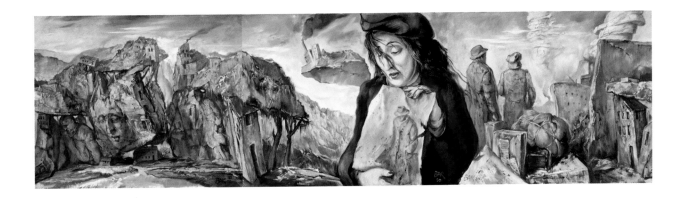

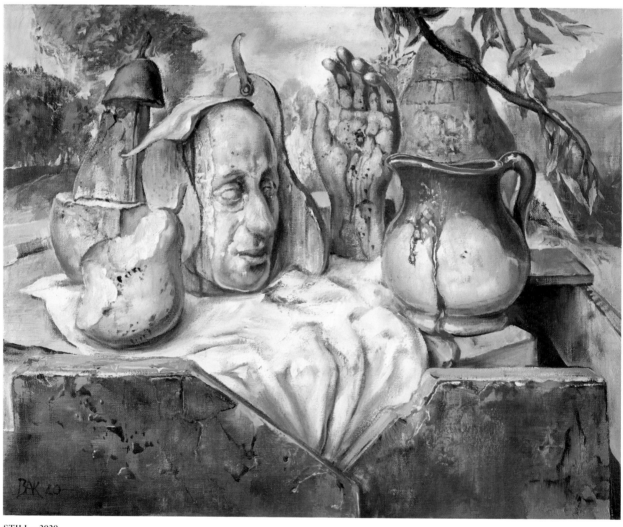

STILL – 2020
Oil on canvas
16 x 20"
BK2678

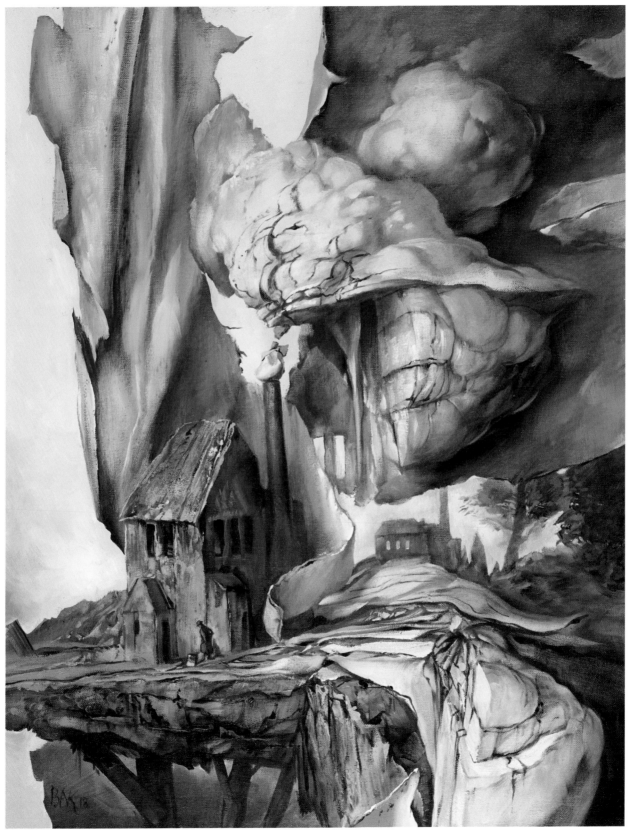

IN SEARCH OF THE KEY ~ 2018
Oil on canvas
28 x 22"
BK2703

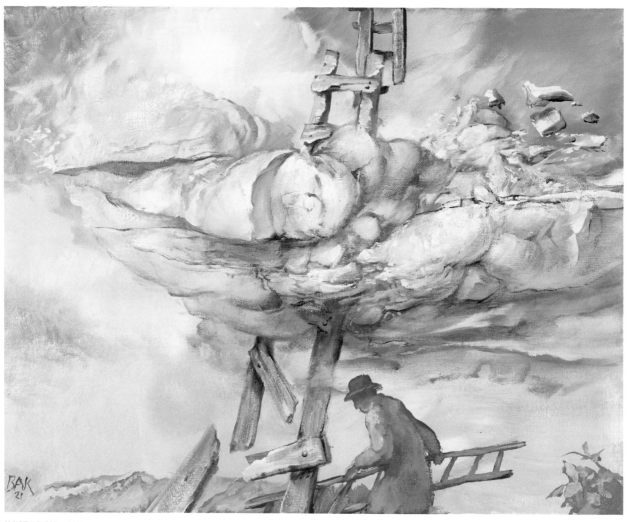

IN SEARCH - 2021
Oil on canvas
14 x 18"
BK2657

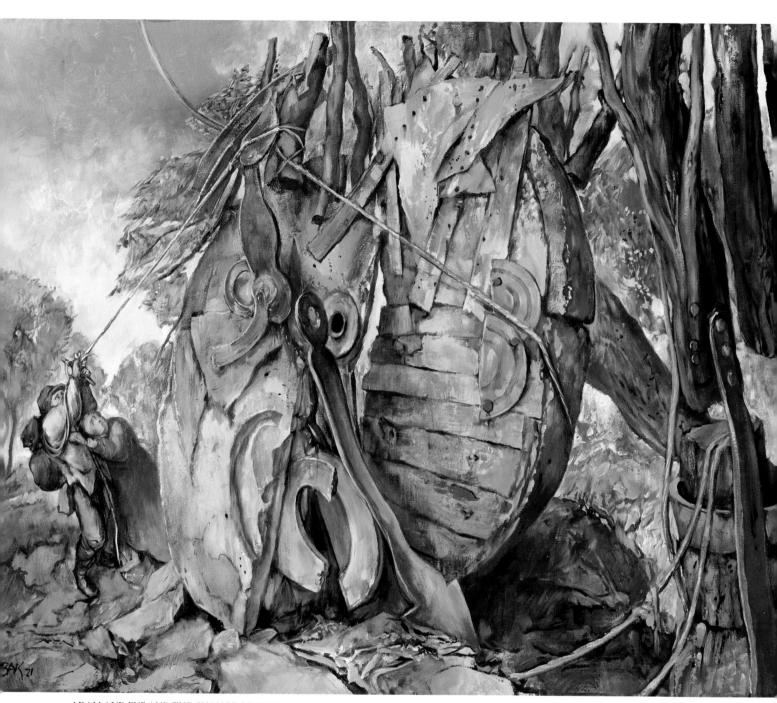

ADAM AND EVE AND THE CHANGE OF TIME - 2021
Oil on canvas
25.5 x 32"
BK2707

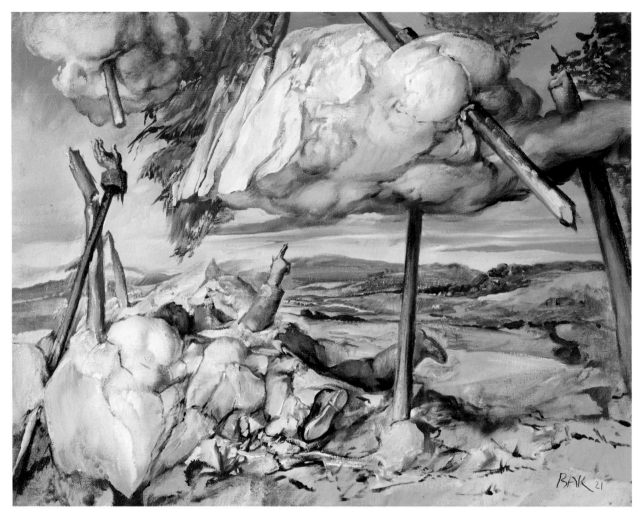

GLOBAL ~ 2021
Oil on canvas
14 x 18"
BK2651

Right: DEBATE, UNENDING ~ 2020
Oil on linen
40 x 30"
BK2712

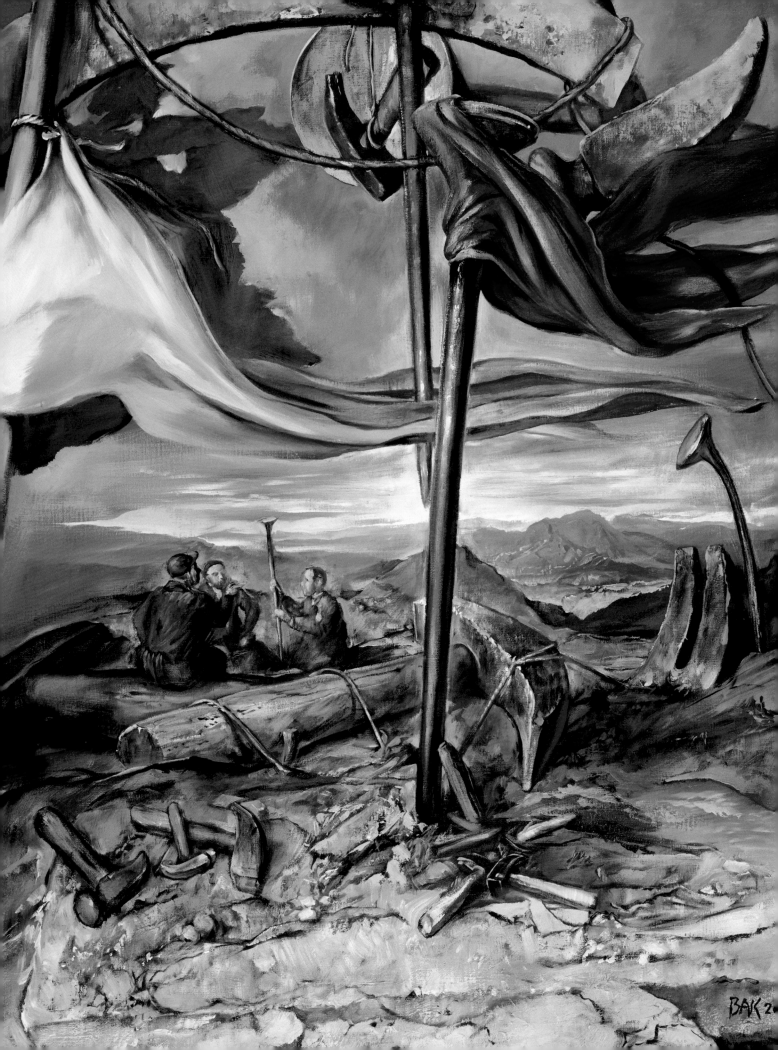

IN A LANDSCAPE WITH MENACING CLOUDS ~ 2021
Oil on canvas
14 x 18"
BK2659

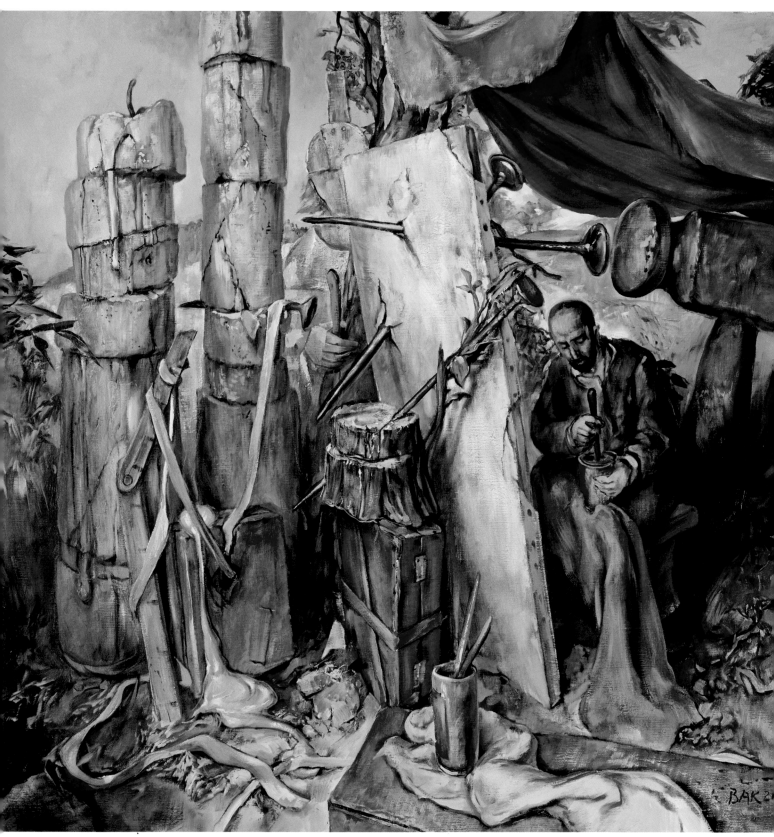

BRUSHWORK ~ 2021
Oil on linen
36 x 36"
BK2710

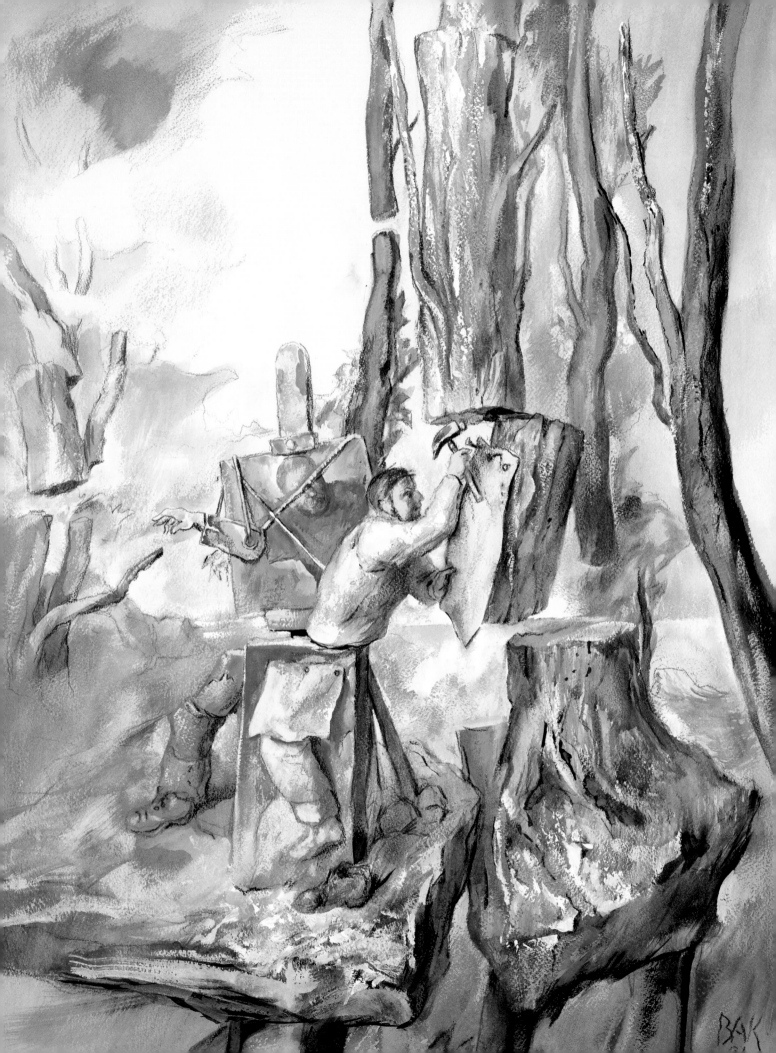

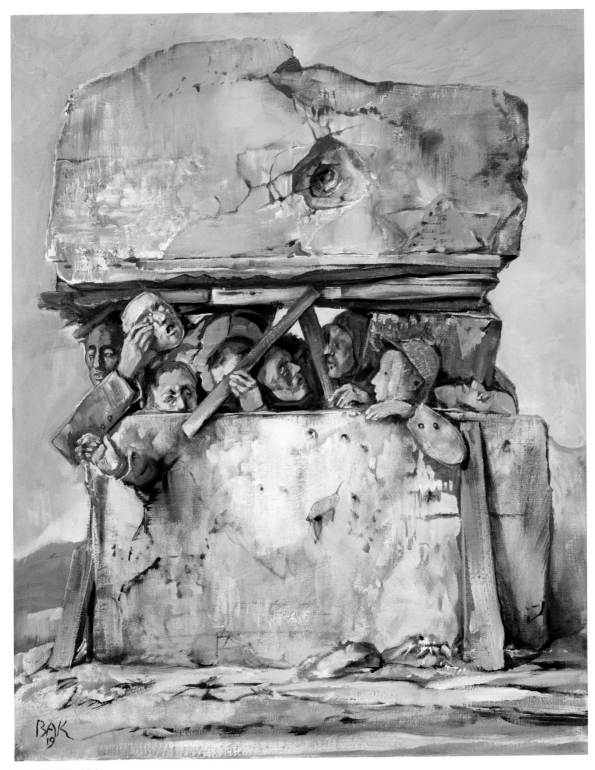

INEVITABLE ~ 2019
Oil on canvas
20 x 16"
BK2588

Left: REPAIRMEN ~ 2021
Gouache, watercolor, and crayon on paper
30 x 22.25"
BK2725

114

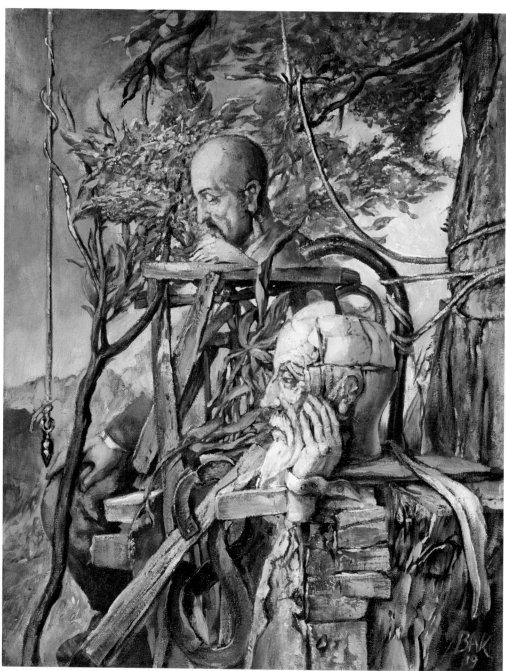

INFINITELY AND MORE ~ 2019
Oil on canvas
20 x 16"
BK2685

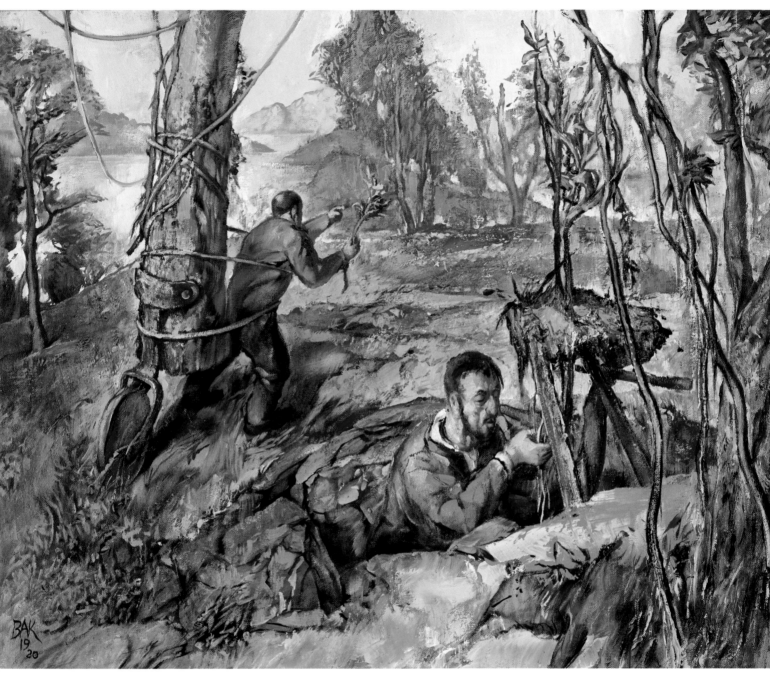

SHARED PURPOSE ~ 2019–2020
Oil on canvas
22 x 28"
BK2599

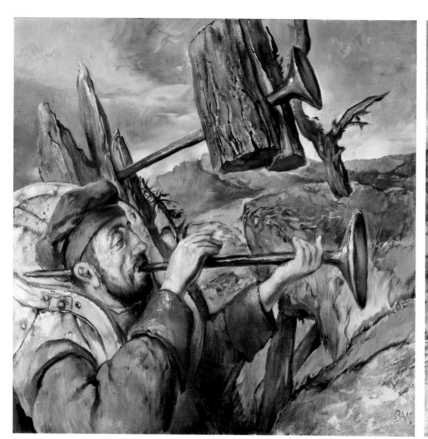
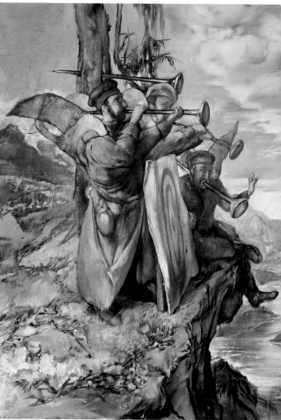

TRIPTYCH OF THE PERPETUAL WARNING, A-C ~ 2021
Oil on canvas
20 x 20" each
BK2690-BK2692

ONCOMING CROWD ~ 2021
Charcoal, pencil, and oil on yellow paper
8.5 x 11"
BK2723

FOR THE ONES THAT ESCAPED ~ 2021
Gouache on paper
11 x 15"
BK2720

Right: FOR A NEW HOME ~ 2019–2021
Oil on linen
40 x 30"
BK2586

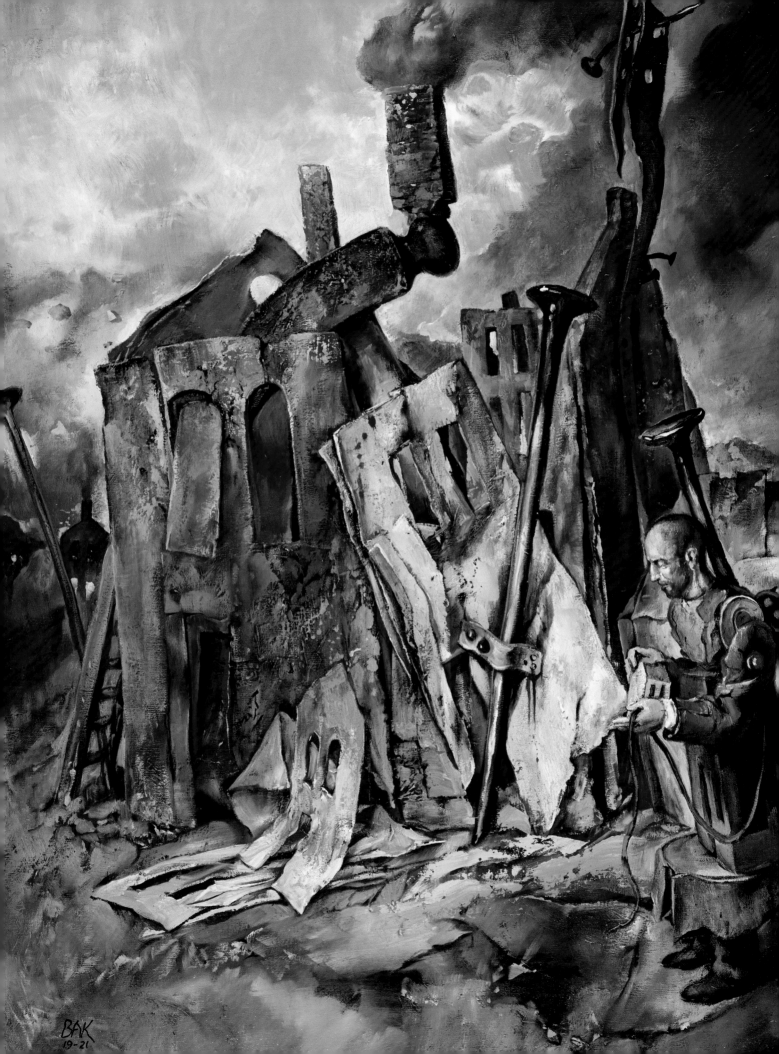

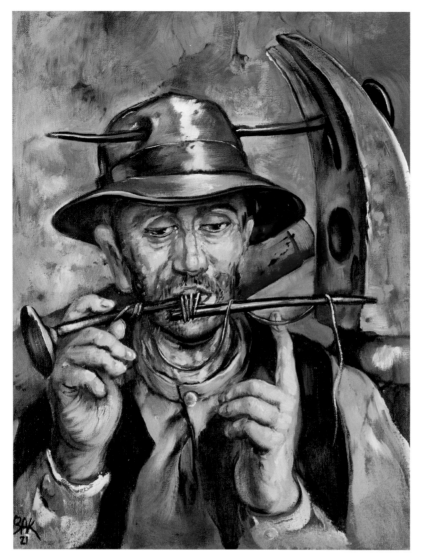

VERBAL REPAIR ~ 2021
Oil on canvas
18 x 14"
BK2665

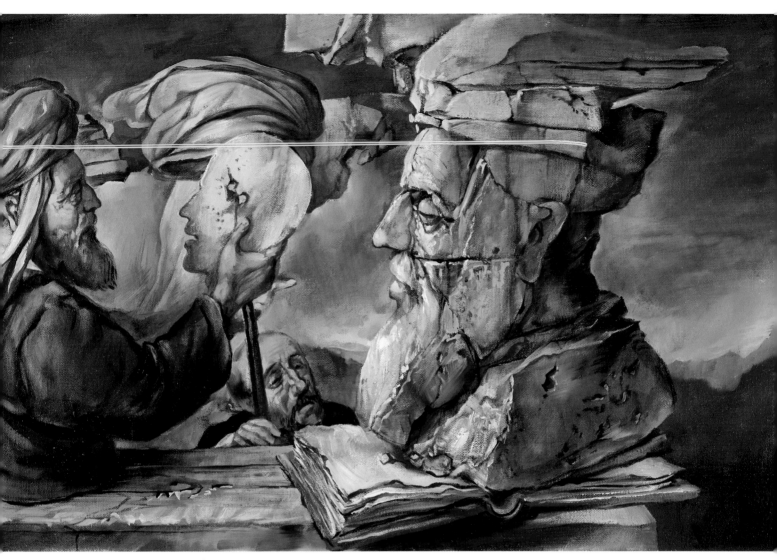

INTERMINABLE DEBATE ~ 2018
Oil on canvas
15.25 x 30"
BK2699

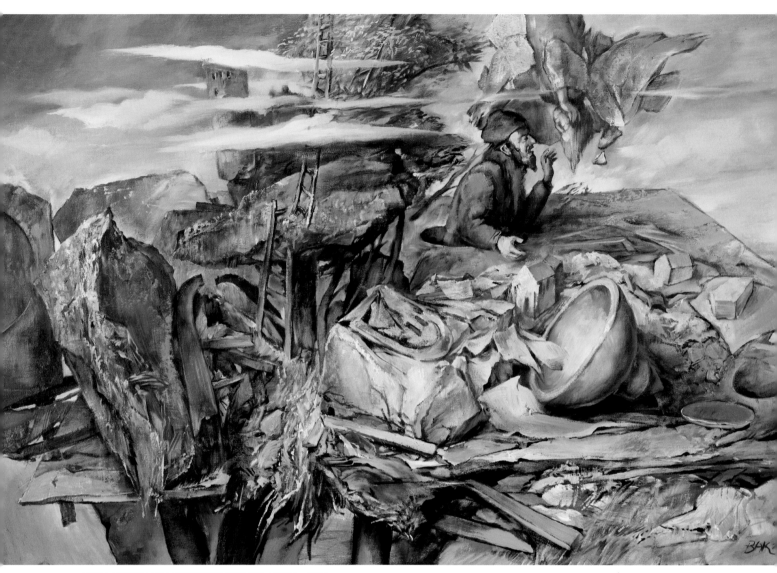

THE LANDSCAPE ARCHITECT AND HIS ANGEL ~ 2021
Oil on canvas
24 x 36"
BK2708

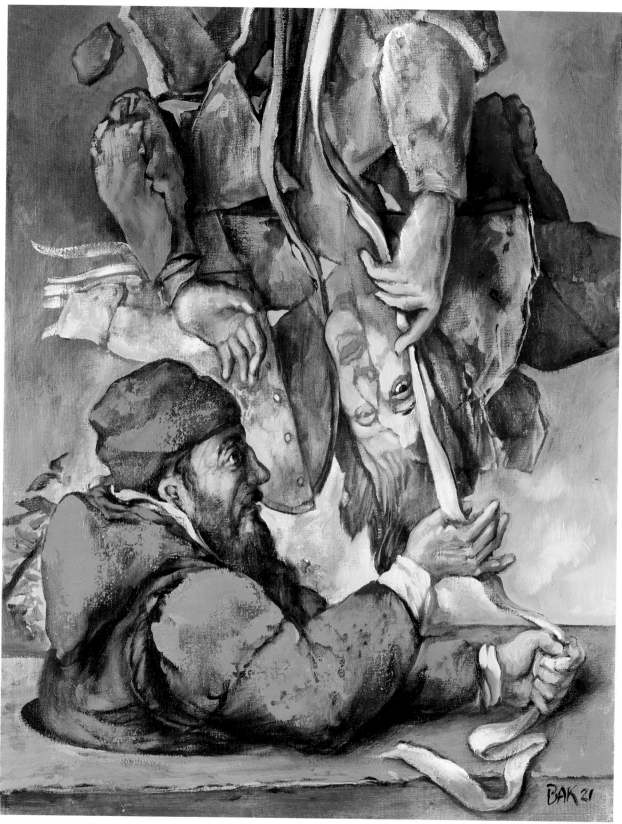

SECRET CONVERSATION ~ 2021
Oil on canvas
18 x 14"
BK2664

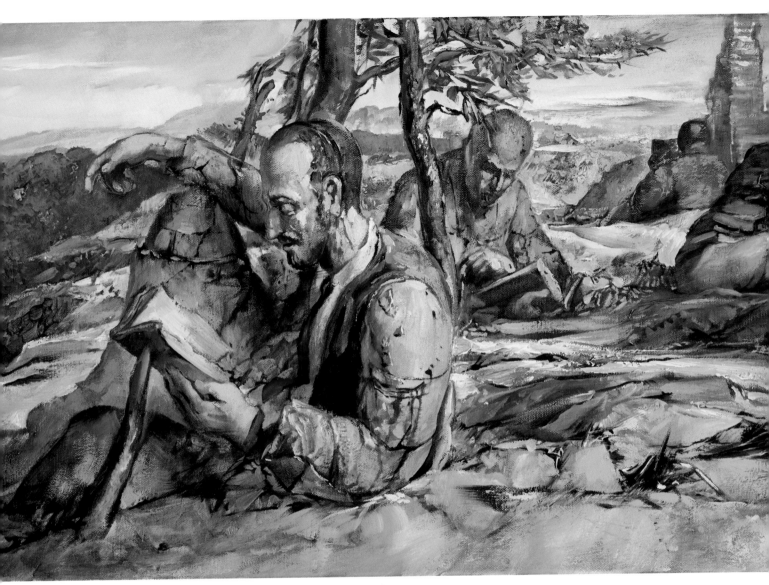

STUDY FOR THE FOUR READERS OF THE APOCALYPSE ~ 2017–2019
Oil on canvas
15 x 30"
BK2624

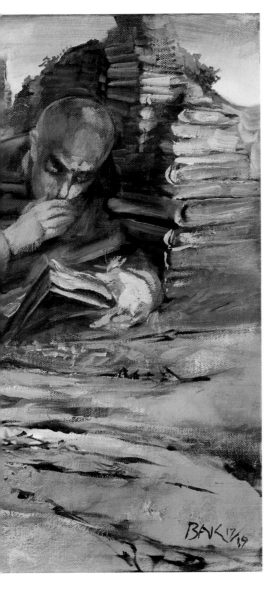

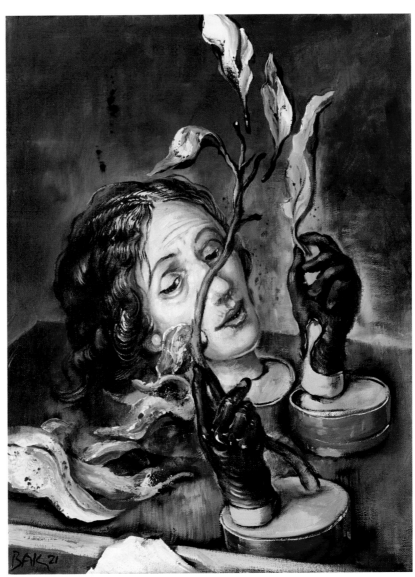

SCATTERED LEAVES - 2021
Oil on canvas
18 x 14"
BK2666

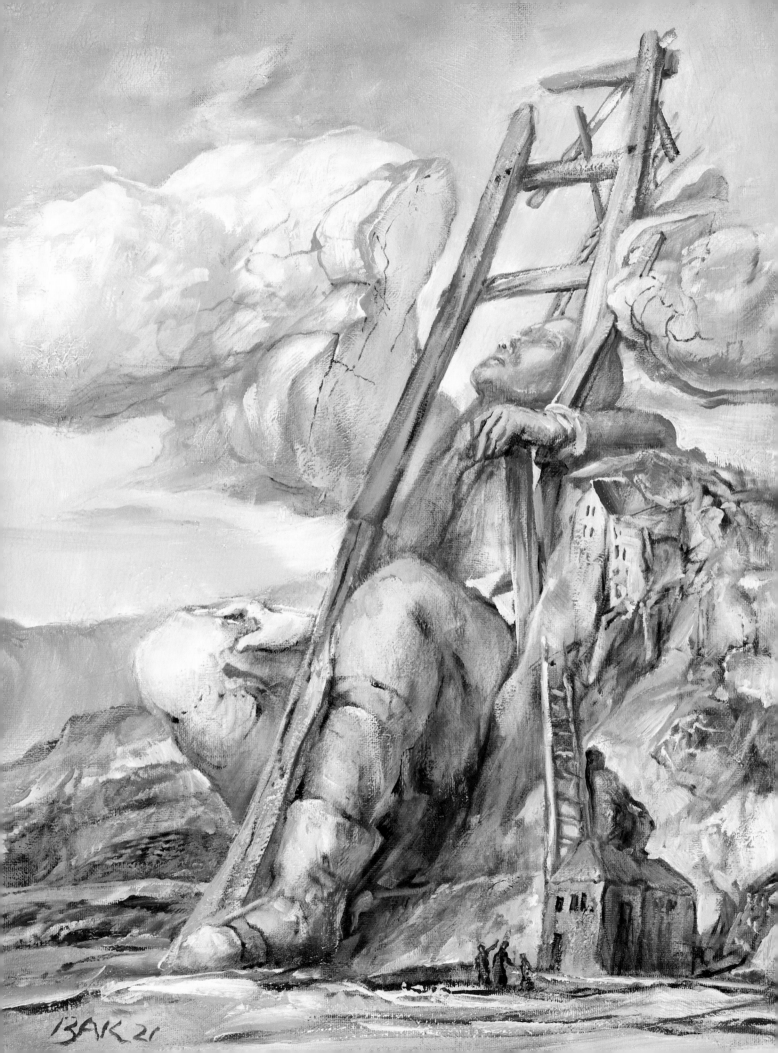

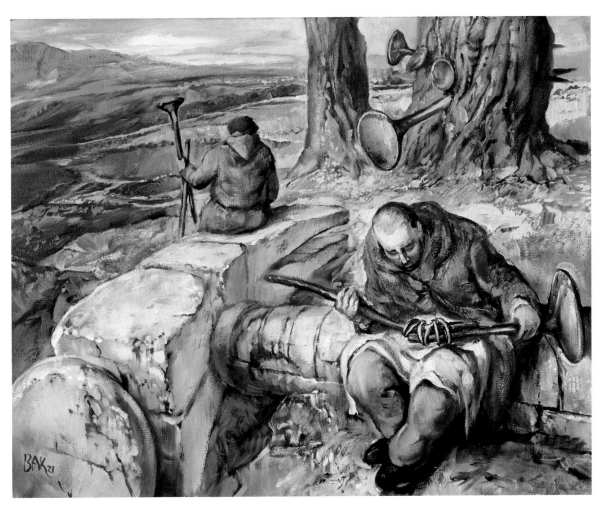

THE OTHER REPAIRMEN ~ 2021
Oil on canvas
16 x 20"
BK2680

Left: JACOB'S SLUMBER ~ 2021
Oil on canvas
18 x 14"
BK2592

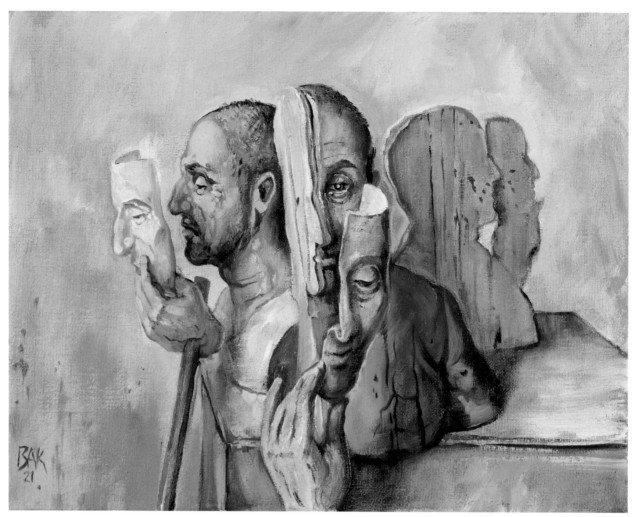

COMPARINGS ~ 2021
Oil on canvas
11 x 14"
BK2671

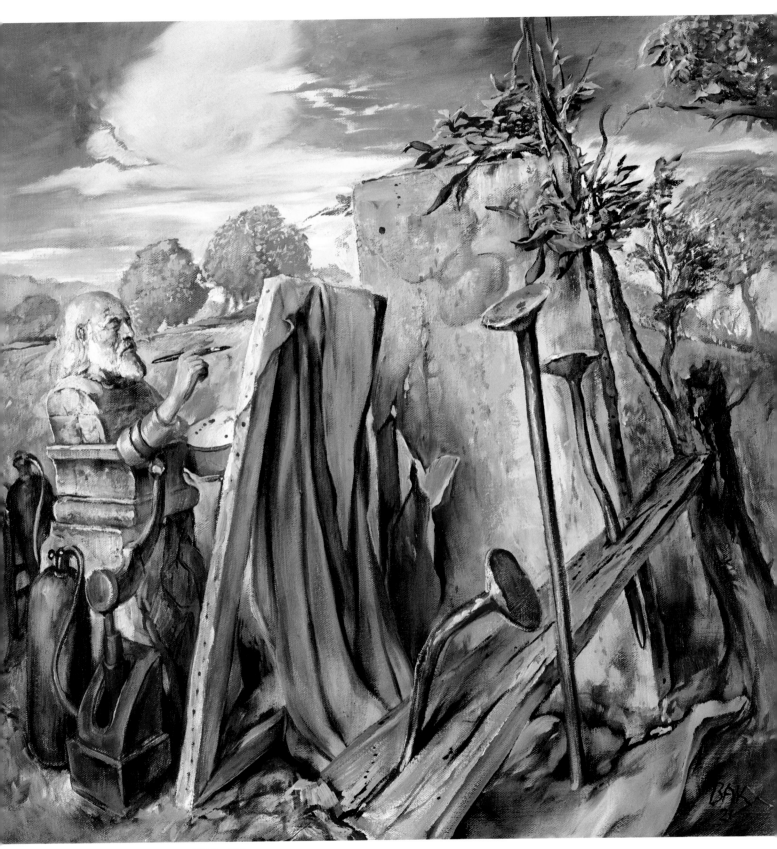

THE ART OF UNDERPAINTING - 2021
Oil on canvas
24 x 24"
BK2695

IN SEARCH OF A CROWD ~ 2021
Pencil on paper
5.75 x 10.75"
BK2722

BRAINSTORM ~ 2021
Watercolor, pencil, and oil on paper
7.75 x 5.75"
BK2721

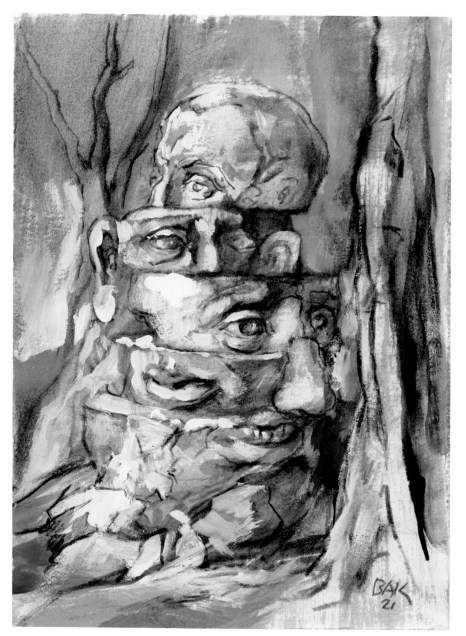

LOOKING FORWARD ~ 2021
Charcoal and alkyd on brown paper
9.75 x 9.75"
BK2719

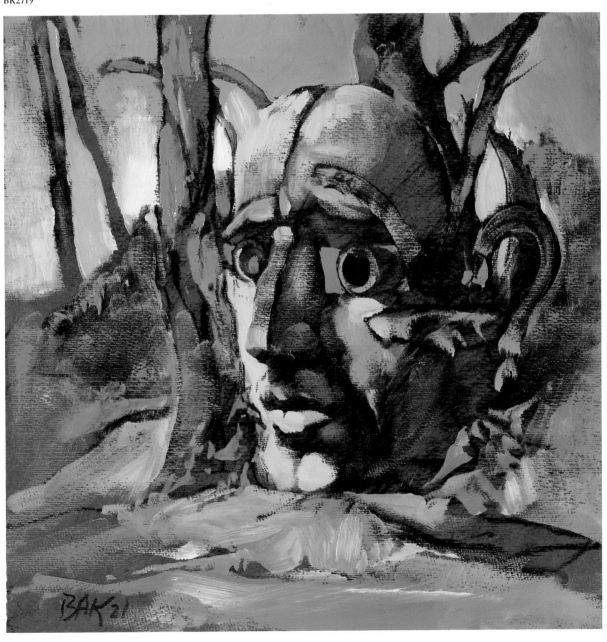

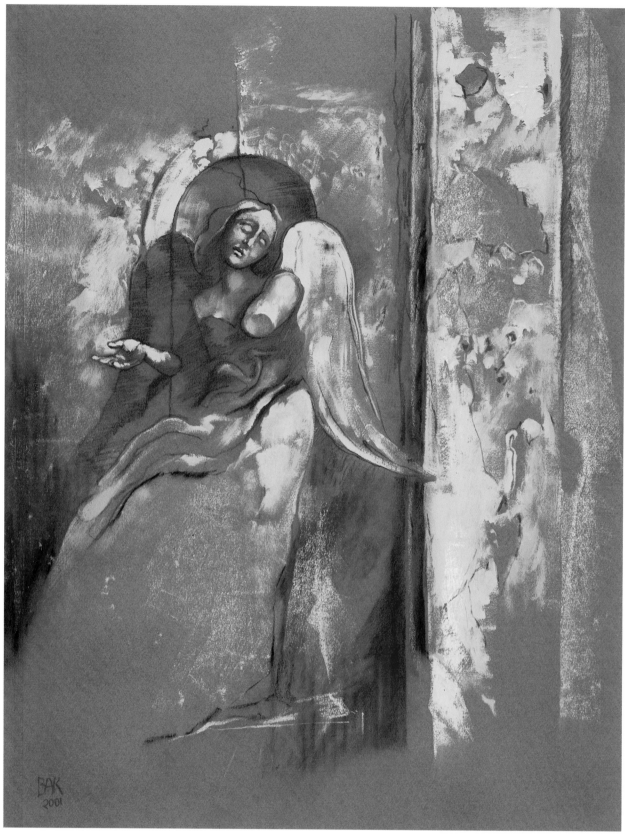

VILNA'S ANGEL ~ 2001
Mixed media on brown paper
25.5 x 19.75"
BK2718

SAMUEL BAK

BIOGRAPHY

~

Samuel Bak was born in Vilna, Poland in 1933, at a crucial moment in modern history. From 1940 to 1944, Vilna was under Soviet and then German occupation. Bak's artistic talent was first recognized during an exhibition of his work in the Ghetto of Vilna when he was nine years old. While he and his mother survived, his father and four grandparents all perished at the hands of the Nazis. At the end of World War II, he fled with his mother to the Landsberg Displaced Persons Camp, where he enrolled in painting lessons at the Blocherer School in Munich. In 1948, they immigrated to the newly established state of Israel. He studied at the Bezalel Art School in Jerusalem and completed his mandatory service in the Israeli army. In 1956, he went to Paris to continue his education at the École des Beaux Arts. He received a grant from the America-Israel Cultural Foundation to pursue his artistic studies. In 1959, he moved to Rome where his first exhibition of abstract paintings was met with considerable success. In 1961, he was invited to exhibit at the Carnegie International in Pittsburgh, followed by solo exhibitions at the Jerusalem and Tel Aviv Museums in 1963.

It was subsequent to these exhibitions that a major change in his art occurred. There was a distinct shift from abstract forms to a metaphysical figurative means of expression. Ultimately, this transformation crystallized into his present pictorial language. Bak's work weaves together personal history and Jewish history to articulate an iconography of his Holocaust experience. Across seven decades of artistic production Samuel Bak has explored and reworked a set of metaphors, a visual grammar, and a vocabulary that ultimately privileges questions. His art depicts a world destroyed, and yet provisionally pieced back together, preserving the memory of the twentieth-century ruination of

Jewish life and culture by way of an artistic passion and precision that stubbornly announces the creativity of the human spirit.

Since 1959, the artist has had numerous exhibitions in major museums, galleries, and universities throughout Europe, Israel, and the United States, including retrospectives at Yad Vashem Museum in Jerusalem and the South African Jewish Museum in Cape Town. He has lived and worked in Tel Aviv, Paris, Rome, New York, and Lausanne. In 1993, he settled in Massachusetts and became an American citizen. Bak has been the subject of numerous articles, scholarly works, and nineteen books, most notably a 400-page monograph entitled *Between Worlds*. In 2001, he published his touching memoir, *Painted in Words*, which has been translated into four languages. He has also been the subject of two documentary films and was the recipient of the 2002 German Herkomer Cultural Prize. Samuel Bak has received honorary doctorate degrees from: the University of New Hampshire in Durham; Seton Hill University in Greenburg, Pennsylvania; Massachusetts College of Art in Boston; and the University of Nebraska Omaha.

In 2017, The Samuel Bak Museum opened in the Tolerance Center of the Vilna Gaon State Jewish Museum. In addition to the more than 50 works already donated by the artist, the Museum will accept more than 100 works in the coming years, and ultimately build a collection that spans the artist's career. Also in 2017, Samuel Bak was nominated by the Vilna Gaon State Jewish Museum, and subsequently named by the city's mayor as an Honorary Citizen of Vilnius. He is only the 15th person to receive this honor, joining Ronald Reagan and Shimon Peres for their exceptional contributions to Lithuania. In 2019, The Samuel Bak Gallery and Learning Center, In Loving Memory of Hope Silber Kaplan, opened at the Holocaust Museum Houston to house more than 125 works donated by the artist. Also in 2019, the Sam and Frances Fried Holocaust and Genocide Academy and the Natan & Hannah Schwalb Center for Israel and Jewish Studies partnered with Pucker Gallery to create *Witness: The Art of Samuel Bak*, an exhibition of Sam Bak's works at University of Nebraska Omaha.

AFTERWORD

"Art is something seen about something unseen."
~ BROTHER THOMAS

~

The most recent, and in many ways the most demanding collection of works by Samuel Bak, *Figuring Out* sees and makes visible things unseen but profoundly connected to the human condition.

We are ever so grateful to many creative colleagues for their contributions to this monograph: scholars, writers, and thinkers:

> *Larry Langer, who has established a base of Bak questions and challenges consistent with a lifetime of profound responses to a myriad of Holocaust-related writings and artistic efforts. What a privilege to have his incisive exploration of Sam's art.*

> *Andy Meyers, who is recent to the "world according to Bak" and has added fresh insight and interpretations to these new works. His total engagement with opening young and old minds to the questions and joys of our world is a true gift.*

> *Jeanne Koles, our eternal editor who manages the entire process of bringing these books to life. Our thanks for her diligence, devotion, and standard of excellence.*

> *Leslie Feagley, our devoted designer for her ability to present these complex images with intelligence and elegance. The visual questions become an investigation of the unseen, which through the art and its presentation here, is now seen.*

At the core of the dance is Sam. His stunning art continues to excite all who are open to his constant search for the unseen, and we are energized to work tirelessly to repair and improve our world.

Figuring out indeed!

BERNARD H. PUCKER ~ 2021

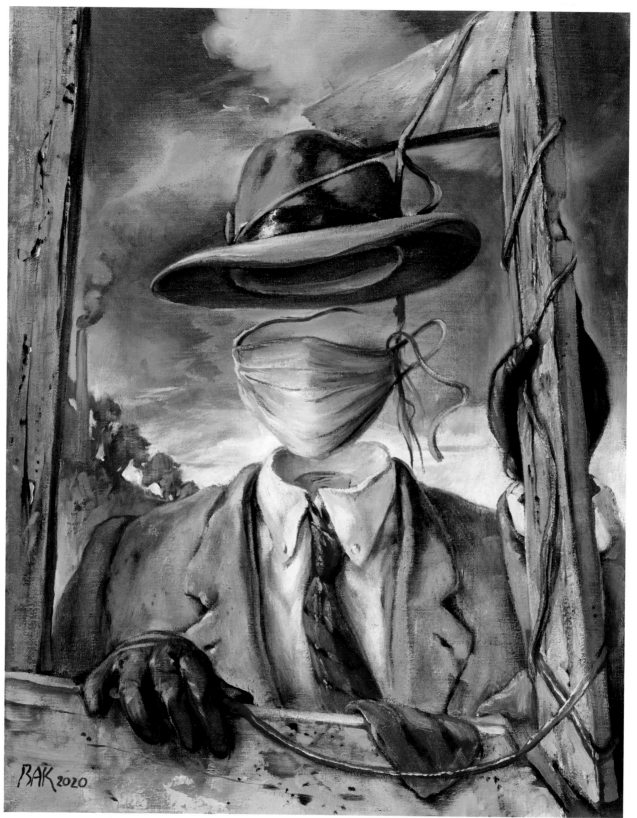

PORTRAIT OF THE INVISIBLE ~ 2020
Oil on canvas
20 x 16"
BK2688